HITLER AND THE ARTISTS

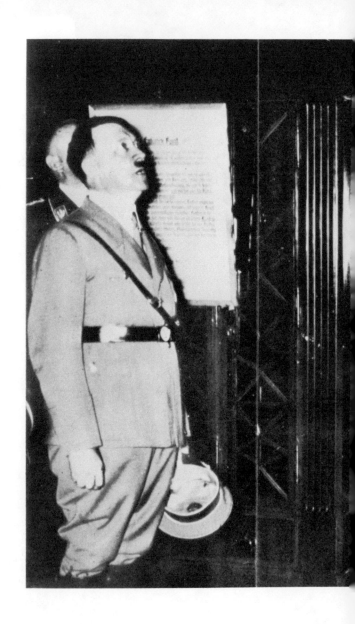

HITLER

BY
HENRY GROSSHAN

AND THE ARTISTS

HOLMES & MEIER
New York · London

First published in the United States of America 1983 by
Holmes & Meier Publishers, Inc.
30 Irving Place
New York, N.Y. 10003

Great Britain:
Holmes & Meier Publishers, Ltd.
131 Trafalgar Road
Greenwich, London SE10 9TX

Library of Congress Cataloging in Publication Data

Grosshans, Henry.
 Hitler and the artists.

 Includes index.
 1. National socialism and art. 2. Germany—
Cultural policy. 3. Hitler, Adolf, 1889–1945. I. Title.
N6868.G69 1983 701'.03 82-21275
ISBN 0-8419-0746-3

Book design by Rose Jacobowitz

Manufactured in the United States of America

Overleaf:
Adolf Hitler examining paintings
by Erich Heckel and Ernst Kirchner at a Nazi-sponsored
"Chamber of Horrors" exhibition of modern art
in Dresden. Here Hitler confronts the work of those
he described as the destroyers of art. Barnaby's Picture Library.

People react as if these paintings were isolated tumors growing in a few sick minds, whereas they are in fact simple and austere first steps in virgin country.

<div align="right">

Franz Marc

</div>

Everything Faustian is alien to me.

<div align="right">

Paul Klee

</div>

For if the Age of Pericles seemed embodied in the Parthenon, so is the Bolshevist present day in a Cubist travesty of a face.

<div align="right">

Adolf Hitler

</div>

If a German government had built a gigantic studio, subsidized the newspapers to declare him the greatest artist of all time, and managed to satisfy his limitless vanity that way, I believe he would have turned to completely harmless pursuits and would never have gotten the idea of setting fire to the world.

<div align="right">

Friedrich Reck-Malleczewen

</div>

One night a gentleman said to me: "Artists are nothing but children."

<div align="right">

Emil Nolde

</div>

To Donna

HITLER

Adolf Hitler,
born 1889, died 1945

THE ARTISTS

Ernst Barlach,
born 1870, died 1938

Max Beckmann,
born 1884, died 1950

Heinrich Campendonk,
born 1889, died 1957

Otto Dix,
born 1891, died 1969

Lyonel Feininger,
born 1871, died 1956

George Grosz,
born 1893, died 1959

Erich Heckel,
born 1883, died 1970

Carl Hofer,
born 1878, died 1955

Ernst Kirchner,
born 1880, died 1938

Paul Klee,
born 1879, died 1940

Käthe Kollwitz,
born 1867, died 1945

Emil Nolde,
born 1867, died 1956

Max Pechstein,
born 1881, died 1955

Christian Rohlfs
born 1849, died 1938

Oskar Schlemmer,
born 1888, died 1943

Karl Schmidt-Rottluff,
born 1884, died 1976

CONTENTS

PREFACE

In the late summer or early fall of 1945, according to the best available evidence, the cremated ashes of Adolf Hitler were blown from the mouth of a Soviet cannon. Over the years our personal and historical memories of the events associated with his life have faded. Thus we often find ourselves in a position similar to that of Rudolf Höss, commandant of the most infamous extermination camp, who, after the war and while in prison awaiting execution, remarked: "Auschwitz? That was far away. Somewhere in Poland."

Yet the interest in Hitler has not slackened. A flood of articles, books, and films has catered to what appears to be an unending fascination with the 4,482 days—twelve years—that Hitler played his important part upon the world stage. Malcolm Muggeridge has claimed that in the nineteen-thirties, "Conversations, whatever their beginnings, had a way of ending in Hitler. It is doubtful if any human being in his lifetime has ever before so focused the attention of his fellows." And Hitler continues to haunt the efforts of all those attempting to make sense of German and European history in this century. He once announced: "Nothing is to be written on my tombstone but the words *Adolf Hitler*. I shall create my own title for myself in my name alone." There is no tombstone. But in a larger sense Hitler was correct. The name is enough.

Historians and others have responded to the challenge of interpreting Hitler and his times. In fact, scholarship upon the Hitler period has been so thorough and so intellectually provoking that anyone tempted to suggest additional words upon the subject is justifiably intimidated. As early as 1934, the Austrian critic Karl Kraus, who had previously never shown any inhibition in declaring his opinions, opened an essay on contemporary politics with the statement: "I have no bright ideas about Hitler." And the disclaimer by Kraus should remain a warning to all who dare to comment upon the person who may have been, no matter how offensive such a

suggestion, the most influential political figure in twentieth-century European history.

The following pages speak to what we could call a cultural confrontation concerning the place of art in the community and the relationship of an interpretation of art to an interpretation of history. This confrontation is illustrated in dramatic form in the frontispiece, where we see Hitler at an art exhibition in Dresden looking at pictures by Erich Heckel and Ernst Kirchner. Here we may have found Hitler as close to modern art as he was ever to be. There is no indisputable evidence that he ever met or spoke with anyone we would call a modern artist. As he was to say in a speech of 1935: "I shall not allow myself to be drawn into endless debates with men who—to judge from their achievements—are either fools or knaves."

Hitler did see himself as the protector of what he regarded as the genuine European artistic image, and his interest in the type of painting and sculpture that would express the society he was building was steady and abiding. In his "Chaos in Poetry," D. H. Lawrence notes that "Man must wrap himself in a vision, make a house of apparent form and stability, fixity. In his terror of chaos, he begins by putting an umbrella between himself and the everlasting whirl. Then he paints the underside of the umbrella like a firmament. Then he parades around, lives and dies under his umbrella." So it was with Hitler. He was determined that the aesthetic firmament of Nazi Germany should express what he saw as valid European artistic principles, should reflect the struggle for a certain type of European society. In pursuit of this goal, he found himself in conflict with those we think of as the significant German painters and sculptors of the time, and the controversy illustrates the aesthetic crisis that has been present in the Western world during the past eighty years.

Hitler as an artist in politics should be taken seriously. He did pose, if in a contorted, even vulgar fashion, interesting questions about our aesthetic judgments and our history. In a speech at the 1937 Nazi party rally, he argued that 95 percent of the national German treasure consisted of cultural achievements and only 5 percent of "the so-called material assets." He was devoted to what he thought of as high culture, and an important part of his historical interpretation was related to his attempt to protect this culture from what he believed were forces dedicated to its destruction. Hitler accepted the contention that art is the litmus paper of a great civiliza-

tion, and as he saw himself as a defender of racial purity, so, equally, he found himself engaged in the struggle to protect aesthetic purity.

Some might argue that a serious examination of Hitler as one interested in art is to ignore important and horrifying aspects of his career. Such cannot be my intention. No discussion of Hitler can be divorced from the historical context in which he is forever fixed. The novelist Alfred Andersch has said of the words *Hitler* and *Auschwitz:* "I could not have invented them, and I refuse to consider for a single moment the possibility of not being able to recognize them. Their meaning is established once and for all." With Hitler we made what has been termed a journey to *anus mundi*—which we might roughly translate as the rectum of the world. And the implications of such a voyage are with us always. It is instructive to recall that when Louis Snyder compiled his *Encyclopedia of the Third Reich*, his first informative entry was the phrase *AB Aktion—ausserordentliche Befriedungsaktion* (extraordinary pacification action)—the code name given to the liquidation of intellectuals and political leaders after the German invasion of Poland in 1939, and his final entry was *Zyklon B*, the poison gas used at the extermination camps.

HITLER AND THE ARTISTS

1

THE ARTIST
IN
POLITICS

"This cleansing of our culture must be extended to all fields. Theater, art, literature, cinema, posters, and window displays must be cleansed of all manifestations of our rotting world and placed in the service of a moral, political, and cultural idea."

Adolf Hitler[1]

In December 1937, the German sculptor and dramatist Ernst Barlach, sixty-seven years old, ill, and the object of almost continual Nazi harassment, wrote to one of the few friends to whom he could speak openly: "My calendar for the year is full of black marks. . . . On H's birthday on April 20 began the uproar; in celebration of that day my *Warrior of the Spirit* was torn out of the university church at Kiel."[2] Coincidentally or by design, on Adolf Hitler's forty-eighth birthday, Barlach's fifteen-foot-high bronze of an angel with sword held upright in front of face and chest and standing on a demon in

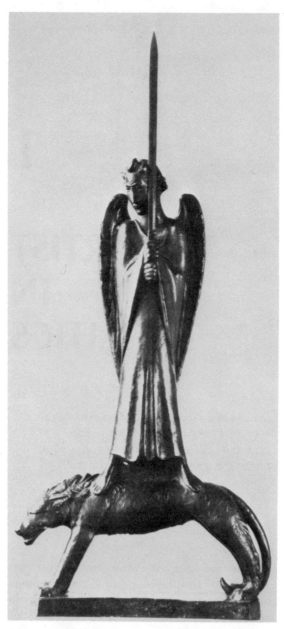

Ernst Barlach's *Warrior of the Spirit* was removed
from public view on Hitler's forty-eighth birthday in
1937, and Barlach was condemned as an artist alien
to the German people. The Minneapolis Institute
of Arts.

animal form was removed from public view and smashed (although a cast was to survive). Seven years earlier, in 1930, Barlach had noted that the Nazis "are instinctively my enemies . . . ; they will make short shrift of me when the hour comes."[3]

Barlach's prediction had proved correct. The political success of Hitler in 1933 resulted in endless troubles for the artist who had been described as the German Rodin, whose long, creative life stretched back over three decades, and whose work had been crucial to the explosion of German art in the early years of the twentieth century. Approximately two months after Hitler became chancellor, Barlach wrote that "My little boat is sinking fast. The louder the Heils roar, instead of cheering and raising my arm in Roman attitudes, the more I pull my hat down over my eyes."[4] And, increasingly, he found himself out of step and out of time. He was condemned as a cultural degenerate, was forbidden to exhibit ("no exhibitions of my work are possible. In Spain this is called garroting, asphyxiation"), was expelled from the Prussian Academy of Arts, and was even spied upon by members of his own household. Owners of his works were forced to resort to the practice of furtively circulating photographs of their possessions, and books containing reproductions were confiscated and destroyed. His many publicly displayed sculptures were removed one by one, and by the late nineteen-thirties only the *Mater Dolorosa* in St. Nikolaus Church in Kiel and the wood carving *Shepherd in a Storm* in Bremen remained. When he died in 1938, permission to place a memorial plaque on the house where he had been born was refused, and newspaper obituaries were limited by official order to ten lines of simple facts. *Das Schwarze Korps*, the publication of the SS, however, seized upon the opportunity to attack Barlach as un-German, Slavic, unbalanced, a lunatic.[5]

The persecution of Barlach was not unique, and all the leading artists of the German modernist movement became targets of the Nazis. In 1933 Heinrich Campendonk and Paul Klee, who was denounced as a "Siberian Jew" and a "dangerous cultural Bolshevik," were expelled from the Düsseldorf Academy of Art; Max Beckmann was forced to resign his teaching position in Frankfurt am Main; Otto Dix was instructed to depart the art academy in Dresden (his work was condemned as "deeply wounding to the moral feelings of the German people" and as "calculated to sap the people's will for defense"), and Oskar Schlemmer was dismissed from his professor-

ship in Berlin. In 1934 Carl Hofer was discharged from his post at the art school in Charlottenburg. From 1929 to 1932 Ernst Kirchner had prepared designs for murals for the Folkwang Museum in Essen, but in 1933 he and the museum were ordered to abandon the project. In 1924, on the occasion of his fortieth birthday, Beckmann had been honored with exhibitions of his work and by the publication of a luxurious, illustrated volume that contained essays by Germany's leading art critics. On his fiftieth birthday, in 1934, there was no mention of Beckmann in the German press. In 1935 paintings by Emil Nolde, Beckmann, Erich Heckel, and Lyonel Feininger were withdrawn from a Munich show entitled "Contemporary Art from Berlin." Works by Käthe Kollwitz, Barlach, and Wilhelm Lehmbruck were removed from the 1936 Prussian Academy's jubilee exhibition, and in that same year a showing by Christian Rohlfs in Barmen was closed as an offensive display of artistic decadence. Karl Schmidt-Rottluff, Max Pechstein, Hofer, Ludwig Meidner, and Heckel were ordered to cease painting, and Nolde was forbidden to engage in "all activity, professional or amateur, in the realm of art" because of what was described as his "cultural irresponsibility."

Throughout Germany countless paintings, drawings, and pieces of sculpture were taken from galleries and museums and were hidden from view or destroyed. In Berlin, Bremen, Darmstadt, Dresden, Essen, Frankfurt, Hamburg, Karlsruhe, Kiel, Mannheim, Nuremberg, and Stuttgart efforts were made to eliminate what had generally been regarded as the most advanced of twentieth-century German art—and, wherever it was at hand, French art as well—from the German cultural landscape. Pictures by Cézanne, Van Gogh, Gauguin, Rouault, Matisse, Picasso, and Braque were condemned as examples of degenerate art, while the assault upon the works of German artists was thorough and continual. During the twelve years of the Third Reich, over a thousand oil paintings and watercolors by Nolde were removed from German museums; six hundred and thirty-nine of Kirchner's works and over five hundred of Beckmann's paintings were confiscated from public collections; three hundred and eighty-one of Barlach's sculptures were taken from churches and other buildings; three hundred and eleven of the works of Hofer were withdrawn from public view; and six hundred and eighty pictures by Schmidt-Rottluff were stripped from gallery holdings. Over a hundred of Klee's paintings were sold at Nazi-

sponsored auctions (many were bought by Swiss museums); George Grosz had approximately three hundred of his works destroyed; and three hundred and sixty of the works of Dix were seized by Nazi authorities. Among the better-known suppressed pieces were *Mother and Child* by Kollwitz, *Church in Halle* by Feininger, *The Masters of "Die Brücke"* by Kirchner, *All Round the Fish* by Klee, *Carnival in Paris* by Beckmann, and *Fate of Animals* and *Tower of Blue Horses* by Franz Marc. By various circuitous routes, some of the condemned paintings and sculptures, including Cézanne's *Stone Quarry*, one of Van Gogh's most dramatic *Self-Portraits*, Robert Delaunay's *St. Séverin*, Klee's *Twittering Machine*, Kirchner's *Circus Rider* and his *Self-Portrait as a Soldier*, Lehmbruck's *Kneeling Woman*, a cast of Barlach's *Warrior of the Spirit*, and eight of Beckmann's nine triptychs, were ultimately to find a welcome home in the United States.[6]

Attacks upon painters and sculptors for what were regarded as violations of aesthetic propriety and offenses against public morals had been common in Europe since the middle of the nineteenth century, and what some thought of as cultural scandals had periodically aroused heated controversy over the nature of art and the vocation of the artist. Every significant and innovative artist had been, to a greater or lesser extent, the victim of critical scorn and public indignation. In 1863 Edouard Manet caused a sensation in Paris when he exhibited his *Déjeuner sur l'herbe*, which was described as "a shameful, open sore" and "a provocation," and in 1874 the First Impressionist Exhibition appalled many who saw in paintings such as Cézanne's *A Modern Olympia* the products of madness, the works of those who painted "in a fit of delirium tremens." In 1898 Rodin's statue of Balzac was rejected by those who had commissioned it, and the 1910 Post-Impressionist Exhibition in London was described as containing "works of idleness and impotent stupidity." Vincent Van Gogh had been characterized as "a typical matoid and degenerate," and his *Cornfield with Blackbirds* was dismissed as "the visualized ravings of an adult maniac." Even the relatively placid German art scene of the late nineteenth and early twentieth centuries had been disturbed by sporadic complaints and expressions of outrage. Max Liebermann's *The Boy Jesus in the Temple* was condemned by many Germans as blasphemous, and it is reported that the artist's mother avoided appearing in public because of her sensitivity to criticism of her son's work. In 1892 Edvard Munch was invited to show his paintings in Berlin, but the exhibition provoked such angry response

that it was closed after two days. In 1906 the director of the museum in Weimar had been forced to resign because of his efforts to exhibit Rodin's drawings, and in 1909 the director of the National Gallery in Berlin had been dismissed by Wilhelm II because of the Kaiser's dismay at the director's attempts to use the gallery as a showplace for modern art. In 1910 in Munich a showing of the works of Kandinsky, Jawlensky, Picasso, Braque, Derain, and Rouault resulted in widespread opposition on the part of the press and the public.[7]

But these episodes had been sparked largely by arguments over aesthetic taste, and while debate had touched upon such matters as the relationship of the work of art and the health of the society, the mental and spiritual condition of the artist, and the fear of cultural decline, animosities had not been translated into repression. The Nazis, however, introduced into an aesthetic dispute the iron fist of national authority, and for the first time in modern Western European history an official attitude toward art was adopted and conformity to that attitude enforced. Manet, Cézanne, and Van Gogh had been ridiculed, slandered, and, perhaps worst of all, ignored. German artists who offended against what the Nazis thought of as proper aesthetic behavior were regarded as enemies of the state, active promoters of evil, criminals against whom the organized strength of the society should be directed. Modern art was not treated with indifference or scorn. It was outlawed, and the instruments of political power were used to forward a particular aesthetic program throughout Germany.

The Nazi movement attracted many who had a grudge against modern art. There were daydreaming racist philosophers, embittered know-nothings, provincials who seized the opportunity to direct their spite against those engaged in activities they could not understand, small-town bigshots and big-town smallshots. Some of the leading party members took pride in what they regarded as their artistic inclinations and were prepared to speak out on the subject of art and artists. Hermann Goering was a voracious collector of art; Josef Goebbels was a failed novelist and playwright (his novel *Michael: A German Fate in Diary Form* is a true literary curiosity); and even that peddler of pornography and obscenities, the corrupt publisher of the infamous *Der Stürmer (The Stormer)*, Julius Streicher, attempted the writing of poetry and the painting of watercolors. Alfred Rosenberg, the self-styled party philosopher, whose well-known if largely unread *The Myth of the Twentieth Century* was devoted in great part to a consideration of art and its relationship to

society, had in the late nineteen-twenties organized the Combat League for German Culture, a collection of woolly-minded activists, which sponsored exhibitions of modern art with such designations as "Spirit of November, Art in the Service of Sedition" and "Art Bolshevism," and saw himself as particularly qualified to make pronouncements upon cultural affairs. Moreover, a flourishing genre of antimodernist criticism had appeared in the nineteen-twenties, and a number of historians, architects, professors and assorted intellectuals produced a continual flow of warnings about the dangers modern art posed to the German community. Otto Grautoff in *The New Art* stated that what he called "aboriginal utterances on canvas, panel, or paper" were the ruin of true painting; Hans F. K. Guenther was troubled by the artistic conflict between the upper stratum of the Nordic race and the lower, foreign stratum; and Othmar Spann spoke frequently, even incessantly, of what he described as the contemporary cultural crisis in art.

Undoubtedly the most important of these critics of modernism was Paul Schultze-Naumburg, one of Germany's best-known and respected architects and landscape architects, who in the nineteen-twenties became preoccupied with the idea that the artist and the architect portray evidence of their genetic constitutions in their work. Thus "racially pure" painters and sculptors will produce racially pure art, and those of "mixed" blood will be identified by artistic contortions and deviations from the healthy, Germanic model. In his books *Art and Race, The Face of the German House,* and *The German Art* (a copy of the last was in Hitler's private library) Schultze-Naumburg identified cultural decline with racial decline and pressed his argument by reproducing side by side examples of modern art and photographs of human deformities and diseases, thereby equating modern painting with the physically deformed and the mentally deficient. The works of Nolde, Barlach, Heckel, Hofer, and Kirchner were used as illustrations of the illness threatening Germany. When the Nazi Wilhelm Frick became Minister of the Interior and Minister of Popular Education in the province of Thuringia in 1930, Schultze-Naumburg succeeded in purging the museum in Weimar of the works of Barlach, Klee, and Feininger and in having the frescoes by Schlemmer in the former Bauhaus painted over. Frick became Reich Minister of the Interior in 1933, and he brought Schultze-Naumburg with him to Berlin as his adviser on artistic matters.

But, in the nineteen-thirties, the important antagonist of the

modern art movement in Germany was Adolf Hitler, who saw himself as the cultural as well as political leader of the Germans. The *Führer*, in his view, was no mere patron of the arts, no simple presiding officer, no bureaucratic expression of the ideas of others, but the incarnation of those deep aesthetic longings that characterized the Germans, whom he often described as "a people of soldiers and artists." Hitler set the tone for official art in Germany, as he enunciated the aesthetic principles that were to govern creative undertakings in the Reich. He delivered addresses with such titles as "Art and Politics" and "German Art as the Proudest Justification of the German People" (the addresses were printed as separate pamphlets as well as in the press), commissioned the building and supervised the operation of art museums (he insisted that the works of Frans Hals be collected at Linz and Tyrolese landscapes at Innsbruck), and had his own paintings declared "works of art of national importance."[8]

Hitler's comments about art appear in his autobiography, in his speeches, and in his conversations, and they are consistent from the early nineteen-twenties until his death. He was as obsessed with the fear of cultural decline as he was with the threat of biological pollution, and he was the steady enemy of modern art, with what he saw as its incoherence, its rejection of historical purpose and historical will, its emphasis upon the isolated, even alienated, individual, its abandonment of objective time, its restlessness, and its distorted narrative. He believed that modern art was a fraud—what he described as "one single deformed blotch"—and that the confusion of the twentieth century had permitted the acceptance of abnormalities. In 1928 he remarked:

> What we experience today is the capitulation of the intellectual bourgeoisie to insolent Jewish composers, poetasters, painters, who set miserable trash in front of our people and have brought things to such a pass that for sheer cowardice the people no longer dare to say: that doesn't suit us, away with this garbage. No, against their better knowledge and conviction the so-called intellectuals in our nation accept as beautiful something set before them by those people, which they themselves must automatically feel to be ugly. That is a sign of our universal decay, a cowardice that can be thrown to the ground with one slogan: you are a philistine. . . .[9]

He regarded modern artists, in his words, as "cultural Herostrat-

uses" (a reference to Herostratus, who set fire to the temple of Artemis in Ephesus in 356 B.C.) and declared that "every personal dispute with them must therefore have ended in bringing them either into the prison or the madhouse."[10]

Hitler was deadly serious in his aesthetic judgments. In 1937 he ordered inscribed over the door of the recently constructed House of German Art in Munich the words, "Art Is a Mission Demanding Fanaticism," and he was a fanatic in his love and hatred of art, a desperate advocate of what he regarded as beautiful and a frenzied opponent of what he thought of as ugly. As a young man he had been an artist, and he retained to the end of his life an abiding, almost consuming interest in art. His statement in 1942—"It's against my own inclinations that I devoted myself to politics. I don't see anything in politics anyway, but a means to an end. . . . Wars pass by. The only things that exist are the works of human genius. This is the explanation of my love of art."[11]—has been noted by many students of Nazism but seldom regarded as important. Certainly at times he spoke facetiously of his artistic inclinations, as when, during the night of July 21–22, 1941, as the German army moved deep into the Soviet Union, he commented, "My dearest wish would be to wander about Italy as an unknown painter."[12] Yet his vision of himself as an artist is a valuable clue to understanding Hitler. He often defined his historical mission in artistic terms, and, for him, aesthetic awareness was the characteristic that separated the man of genius from others. In the nineteen-twenties he apparently considered the possibility of writing a book about an artistic man of action who molds and saves his people, and he consistently saw himself as one who scorned the historical tasks obvious to those he thought of as political mediocrities and who strove instead for artistic goals that were comprehensible only to a few.

Many of Hitler's personality traits can be related, at least in part, to his artistic temperament. His indifference to bureaucratic routine, his refusal to accept any objective fact that contradicted his intuitive judgments, his hunger for what he thought of as cosmic experience, all may be regarded as characteristics associated with a certain kind of artistic insight, a confidence in a personalized, aesthetic perception of reality. Konrad Heiden noticed that Hitler did appear to fit the definition proposed by the racist philosopher Houston Stewart Chamberlain: "The frivolity with which such an artistic spirit treats facts is inspired in him by the certainty that he will

penetrate to a higher truth regardless from what premises he starts."[13] Hitler's vision of himself as an artist may also account, again at least partially, for his singular aloofness and isolation. He was a solitary man, and even when he enjoyed his greatest triumphs, surrounded by enthusiastic crowds, he appeared strangely alienated. He regarded himself as one who stood utterly alone, engaged largely in a monologue, in the midst of associates whom he thought of as inartistic nincompoops, poor pedants who had little understanding of any artistic ideal. One might recall that in 1945 Hitler pointed out that Heinrich Himmler could not succeed him as ruler of Germany: Himmler was unacceptable to the party, and he lacked artistic feeling.

Hitler considered art the struggle of creative individuals against the resistance of a dull world, a method whereby the prosaic and the ordinary are subjected to the racial and historical will and thus transformed into an ethnic and national revelation. As Robert Gutman wrote of Richard Wagner, so one could say of Hitler that he was convinced there was a true German art that "would turn his countrymen, led astray by the quest for gold and the seduction of French and Jewish pseudo-art, back to the essential greatness and profundity of the German spirit."[14] During the nineteen-thirties Hitler adopted the practice of giving a series of "Art Speeches" at the annual Nazi Party days. These were long-winded orations that were probably beyond the rank and file and even most of the Nazi leaders. But on such occasions Hitler:

> speaks of himself, trying to attain clarity concerning his own nature. Here he speaks of his relation to art, his power and gifts in this field, in which, outwardly at least, he doubtless failed in his youth; and the sense of the whole speech is finally a stubborn, though inwardly uncertain: "Anch' io son pittore." (I too am a painter.)[15]

Some of his more perceptive countrymen remarked upon Hitler's artistic bent, although they often drew differing conclusions. Josef Goebbels suggested that Hitler's methods were those of the authentic artist, while Thomas Mann, in an essay entitled "Brother Hitler," diagnosed Hitler's principal characteristic as a catastrophically neurotic perversion of the artistic impulse. There is no evidence that Hitler read Julius Langbehn's well-known book *Rembrandt as Educator*, but he certainly would have been prepared to accept Langbehn's argument that only great artistic minds are capable of understanding

the German spirit and thus expressing the subjective, patriotic, and racial realities of German society.

Of course, Hitler was a notable political figure in modern European history. He was influenced by military, strategic, and economic considerations. But he was also, perhaps uniquely in the twentieth century, an artist in politics. He saw art and politics as reflections of one another and was convinced that what he thought of as a healthy and vigorous politics must be accompanied by an equally healthy and vigorous art. The history of the Nazi political movement was also the history of Nazi culture, and at the 1935 Nuremberg party rally Hitler pointed out that at the very time when National Socialism and its leaders were engaged in a heroic struggle for existence—what he called a life-and-death struggle—the initial signs of a revival of German art appeared. Artistic activities indicated what Hitler called "the essential force of a people," and in one of his speeches on the relationship of art and politics he announced that, "When the weak, human spirit, pursued by suffering and anxiety, fails in its faith in the greatness and future of its people," art must act as the sustaining reminder of German historical authenticity, "pointing to those evidences of the inner imperishable and highest value of a people which no political or economic distress can destroy."[16] Thus Hitler's search for the heroic in art complemented his attempt at the heroic in history, as his aesthetic resentments reinforced his political animosities. He was an extreme anti-Semite; he despised what we think of as liberal political values; and he was unswerving in his hatred of modern art. And these various antagonisms paralleled each other. Blood and race will once again become the source of artistic intuition, declared Hitler, and in pursuing this goal he set himself against the architecture of Gropius and Corbusier, against the music of Schoenberg and Stravinsky, against the painting of Picasso and Kandinsky, against what we describe as the spirit of the modern. He spoke often of the "scores to be settled with our criminals of the world of culture," and he regarded modern art as an outstanding example of that "world sickness" which threatened to bring ruin upon Europe. What Hitler called "a battle for the destiny of the German people" was to be fought everywhere, and not least in the arena of art, which, in his words, is a witness of "the people's moral right to life" and which, because it "forms the most uncorrupted, the most immediate reflection of the life of the people's soul, exercises unconsciously by far the greatest direct influence upon the masses of the people."[17]

Any consideration of Hitler's aesthetic inclinations and of their relationship to his general philosophy of history is certain to encounter the difficulties associated with what could be called the Hitler problem. In spite of the biographies, commentaries, and analyses that have marked the past three decades, Hitler remains for many a detached, somewhat mysterious figure, similar to a character in an old newsreel, floating into our view, flickering fitfully before us and then disappearing. Even the most striking literary reference to Hitler is apt to provoke more confusion than enlightenment. In Richard Hughes' *The Fox in the Attic* we are told that "Lance-corporal Hitler was always the odd man out." And we nod in agreement, although we are not certain why we should do so. The sharp-tongued and disenchanted Friedrich Percyval Reck-Malleczewen, in his *Diary of a Man in Despair*, described Hitler as "the stereotype of the headwaiter," a man with "a jellylike, slag-gray face, a moonface into which two melancholy jet-black eyes had been set like raisins." Again, we sense that such a description must be appropriate. A character in Alfred Andersch's novel *Efraim* speaks of Hitler's "narrow, rigid, abysmally gloomy murderer's face, that face which changed only when the mouth opened wide to eject its knife-like scream." But George Orwell thought Hitler's "a pathetic, dog-like face, the face of a man suffering under intolerable wrongs. . . . The initial, personal cause of his grievance can only be guessed at; but at any rate the grievance is there. He is the martyr, the victim, Prometheus chained to the rock, the self-sacrificing hero who fights single-handed against impossible odds."[18] All these quick and dramatic descriptions may, in some measure, be correct, but they provide little assistance in our attempts to understand the astounding and disquieting career of this ruler of Germany and the greater part of Europe, of this demonic world-shaker.

For anyone Hitler is an intimidating figure. How does one cope with the calamitous magnitude of the events associated with his life? So much blood, so much death, such wild historical dreams. Our intelligence seems too weak for the task of historical understanding, and one is tempted to dismiss any rational commentary upon Hitler as a fruitless effort to portray the unportrayable, to speak the unspeakable, to explain the inexplicable. Thus, in her review of Hans-Jürgen Syberberg's *Hitler—A Film from Germany*, Susan Sontag points out that Syberberg "denies that the events of Nazism were part of the ordinary workings of history." Rather, he attempts "to conjure up the ultimate subjects: hell, paradise lost, the

apocalypse, the last days of mankind," to "evoke 'the big show' called history in a variety of dramatic modes—fairy tale, circus, morality play, allegorical pageant, magic ceremony, philosophical dialogue, *Totentanz*—with an imaginary cast of tens of millions and, as protagonist, the Devil himself."[19] The Swiss dramatist Friedrich Dürrenmatt has explained why Hitler could not be portrayed on the stage:

> Hitler and Stalin cannot be made into Wallensteins; their power was so enormous that they themselves were no more than incidental corporeal and easily replaceable expressions of that power; and the misfortune associated with the former (Hitler) and to a considerable extent also with the latter (Stalin) is too vast, too complex, too horrible, too mechanical, and usually simply devoid of all sense.[20]

In his study of the literary response to the most extreme example of Nazism in action, Lawrence Langer, in *The Holocaust and the Literary Imagination*, argued that perhaps no one could ever clarify satisfactorily or portray adequately this overwhelming human disaster, and the human spirit balks when confronted with the horrors of the Hitler period. The most jaded student of history is pulled short when he or she discovers that the Russians found at Auschwitz enough canisters of poisonous gas to kill an additional fifty million people and gains some apprehension of why the writer Elie Wiesel, an inmate of Auschwitz, upon being asked if he believed what had happened in the camp, replied: "I do not believe it." Perhaps as an indication of the inhibiting nature of the experience with Hitler, Charlotte Beradt, in her *The Third Reich of Dreams*, reports only one instance when a victim of Hitler's wrath dreamed of protesting directly against the chief source of his suffering: an emigre journalist in Prague stated, "I often dream that I am flying over Nuremberg, lasso Hitler, pull him right out of the party Congress, and drop him in the English Channel."[21] The study of Hitler does numb the brain of the investigator and does encourage perverse and frivolous speculations. Can anyone who loves Europe accept the proposition that Hitler put an end to much of the glory of Europe and changed the direction of European history? How obnoxious such a possibility is. We contemplate Klee's sketch entitled *Ein Stammtischler* or *An habitué* (A Regular Customer), so reminiscent of Hitler, with its small-minded demonism, its indistinct but recognizable features, its ambiguities, its half-concealed mockery, and its slatternly formlessness,

and we despair of our ability to grasp the essence of this nightmare quality, this suggestion of a most prosaic yet elusive nature.

Hitler possessed none of the richness of personality, none of the subtle human color, upon which a historian depends for understanding. One finds no deep-running, internal dialogue, no striking insight into the complexity of the human situation. The Augustinian contention that man is a great deep seems inappropriate, even absurd, in discussing Hitler. In the torrent of words he spoke, there is no phrase, no *bon mot*, no sentence, that remains lodged in the mind as a memorable example of the fertility of the human imagination. He was both garrulous and tongue-tied, pathetically straining to express what he regarded as winged ideas and inevitably producing vulgarities. Few of the comments made by those who knew him are particularly instructive or provide unique and penetrating observations, and anecdotes relating to him are coarse and lacking in true humor. Cartoons of Hitler are gross and simplistic, and attempts of actors to portray him have been disasters. (Charlie Chaplin's *The Great Dictator* was an awesome tour de force but, quite properly, made no pretense of providing a historical interpretation.) His private life appears commonplace beyond belief, and his recorded efforts at personal or social relationships seem almost incongruous. Albert Speer, the most observant of his Nazi colleagues, wrote that if Hitler had permitted himself to have friends, Speer would have been his friend. But Speer presents a wooden, pedestrian figure in his descriptions of Hitler, and we are left with a man who appears all surface and no depth, and who remains dumb to our questions.

These difficulties have undoubtedly been responsible for the fact that commentary upon Hitler has often involved the rather ridiculous search for sensational detail in the naive belief that historical meaning could be milked from a revealing, at times even salacious, "secret," from some hidden love story, from some extraordinary perversion. Long-distance psychoanalysis has become a disease in much examination of Hitler, and it is common to find him described as "a neurotic psychopath bordering on schizophrenia" or as "a neurotic who lacks adequate inhibitions." A large number of scholars and semischolars have engaged in a variety of titillating speculations about Hitler's rumored if unsubstantiated difficulty in achieving a satisfactory orgasm, about his boyhood quarrel with his father, about the fact that he occasionally carried a bullwhip, that he may have practiced some form of sexual aberra-

tion, even that he was a nonsmoking, nondrinking, perhaps non-copulating, vegetarian. Some students ponder the knowledge that the physician attending Hitler's mother in her final illness was a Jew and attempt to relate his anti-Semitism to such an event. Others examine the photographs of Geli Raubal, Hitler's niece, to whom he was perhaps romantically attached, and who committed suicide in 1931 under somewhat mysterious circumstances, and sense some fatal hurt, some unending grievance against the world. Interpretations such as these may provide assistance in understanding Hitler. But they should not be pushed to ludicrous lengths, must not become a form of historical voyeurism, cannot substitute a pattern of intellectualized gossip for historical comprehension. Thus Volodymyr Walter Odajnyk, in his *Jung and Politics*, may have inadvertently helped to clear the air when he wrote of Hitler:

> His initial psychological condition seems to have been characterized by intense oedipal conflict, repercussions from the early death of his parents, a fixation on adolescent rebellion, poor social adaptation, an ambivalent attitude toward women, similar ambivalence toward authority and domination, passive feminine qualities, latent homosexuality, apparent monorchism, feelings of inferiority, masochism, coprophagic tendencies, the fear of death, hypochondria, and an inclination toward hysteria.[22]

The only response a weary reader can have to such a catalog is relief that surely nothing further could be added to this exhaustive and indiscriminate bill of particulars.

Hitler lacked civility, his hatreds were deep and lasting, and he was driven by rage. But heightened despair and anger cannot merely be interpreted as the identifying marks of a psychopath. They are also motivating forces of history and must not be obscured by any relegation to a psychiatrist's file. Anti-Semitism is vicious and unacceptable, but it is not simply the product of a diseased mind. An outdated allegiance to a racial nationalism is a dangerous historical hallucination, but it is not necessarily evidence of mental illness. A political leader who is convinced of his own infallibility is certainly a threat to all about him. But the activities of such an individual are not exclusively compensation for a warped sexuality.

Similarly, we should be suspicious of those who so readily, and so casually, dismiss Hitler as an uneducated ignoramus. He was

not a demented paperhanger or a crackpot housepainter, nor is it particularly enlightening to speak of him as a petty bourgeois or as a wild-eyed bohemian. Unquestionably, his language was inflammatory and crude, his mind was not attuned to what are usually regarded as subtle intellectual distinctions, and his vision of the world strikes us as grotesque. His unjustified confidence in his knowledge of everything from the operation of railroads to British rule in India is unbearable, and, perhaps for the only time, one can sympathize with the German generals who during the early nineteen-forties on the Russian front fought off sleep and boredom while Hitler engaged in all-night tirades on religion, geopolitics, philosophy, and history.

But while he was not by education or association a member of the usually accepted circle of the European intelligentsia (what European politician was?), Hitler was remarkably alert to the intellectual currents of his time. He retained a continual interest and influence in a staggering number of subjects. He designed Nazi banners, armbands, decorative buttons, newspaper layouts, and posters for meetings. He developed the famous party insignia—a disk with a red ring, a white field, and a black swastika. He declared himself dissatisfied with the original plans for the Volkswagen and argued that the automobile should look like a beetle and thus follow the streamlining design of nature. He speculated upon such projects as double-decker railroad trains operating at high speeds, autobahns a dozen meters wide, the development of Scandinavia as a central powerhouse for Europe, and the production of domestic gas from sewage. Hans Ziegler, director of the German National Theater in Weimar during the Nazi period, relates that Hitler once asked him what kind of stage lighting was to be used for a performance of *Die Meistersinger*. Ziegler replied: "White." Hitler's response was, "Thank God, yes, white." Hitler then pointed out that green or blue light was often used, but such usage was "false and *Kitschromantik*."[23] Near the end of his life Hitler was still dreaming of a new Berlin as a memorial to his triumphs, with the great victory hall capable of holding 150,000 people and with a dome that was to be 1,000 feet high (towering, as Golo Mann said, like a huge fist over the city).

Hitler was, perhaps fatally, attracted to ideas and speculations. In our century only Winston Churchill and Charles de Gaulle among important European political figures possessed an interest in

history equal to Hitler's, as only Georges Clemenceau had a comparable attachment to art. In *Mein Kampf* Hitler stated his intention to grasp and understand the meaning of history, and to search for and to find the forces which cause historical events. Eberhard Jäckel, in his *Hitler's Weltanschauung*, perceptively remarked that Hitler "was fascinated by history, he argued historically again and again, and he had a considerable if idiosyncratic knowledge of history."[24] Hitler maintained that he had read a great deal and pondered what he read as a young man in Vienna from 1908 to 1913, while those who knew him in Munich in 1914 have testified that he spent most of his time in a rented room with "his nose buried in heavy books." He was acquainted with the thought of Nietzsche, Houston Stewart Chamberlain, Ranke, Treitschke, Bismarck, and Spengler. He read military histories, Ibsen's dramas, the librettos of Wagner's operas, and books on mythology. According to his fellow soldiers, Hitler read and reread Schopenhauer's *The World as Will and Idea* during World War I, and he was familiar with the significant volumes in the library of anti-Semitic literature, as well as with the geopolitical theories of Ratzel, Haushofer, and Mackinder, and with Hanns Hörbiger's glacial cosmogony. Werner Maser noted that Hitler was "remarkably *au fait* with the history and culture of antiquity and the numerous Gods and heroes of mythology. He also knew his Bible, being particularly well-versed in the Old Testament."[25] A quick glance at the index to the published version of *Table-Talk*, the edited, stenographic report of Hitler's conversations at his military headquarters in the early nineteen-forties, reveals a large number of references to historical and philosophical subjects, and an occasional comment indicates a surprising insight. In February 1942, during one of his long, nighttime monologues, he declared that *Don Quixote*, *Robinson Crusoe*, *Gulliver's Travels*, and *Uncle Tom's Cabin* were what he called "universal works." He then went on to say that "Cervantes' book is the world's most brilliant parody of a society that was in the process of becoming extinct" and that "Daniel Defoe's book gathers together in one man the history of all mankind." (Had Hitler actually read *Don Quixote* or had he fastened upon a commonplace of literary criticism that had in some way drifted into his mind?) And he did add, correctly and unexpectedly, in light of his animosity toward French artists, that "Cervantes' book has been illustrated by Gustave Doré in a style of real genius."[26]

One need hardly say that all this had nothing to do with institutionalized education or learning. It is well known that Hitler despised experts and, as did T. E. Lawrence, regarded such specialists as intelligences confined within high walls. He was crassly proud of not having gone to school to anyone whose position in society would have brought recognition as a preceptor, and, with infrequent exceptions, his remarks about intellectuals and professionals were derogatory, even insulting. Thus, in a speech of May 10, 1933, he said: "I know the intellectual—always indulging in sophistry, always probing and searching, but always wavering and uncertain, mobile, but never sure."[27] And here we stumble against an often-neglected aspect of modern history. We rather glibly assume, in the face of overwhelming contrary evidence, that the important learning process can only be carried on through structured institutions. Yet when we think upon the matter we are hard-pressed to put forward the name of a single significant political personality of the past one hundred years whose important historical contribution can be clearly related to his experience with some institutionalized pattern of education. Bismarck, Lenin, Lloyd George, Stalin—can these or any of a host of others be regarded as the products of an official education or of participation in a more or less established organization of intellectuals?

It is discouraging to follow the attempts of scholars to interpret Hitler by ridiculing his vulgarity and what are often called his lower-middle-class tastes. Especially is this so when such comments are often made by those whose own knowledge of and critical response to art, literature, architecture, and other such matters are obviously minimal. Many have mentioned Hitler's long love affair with Wagner's music. And there may be something unhealthy about losing oneself in the rich lushness of Wagnerian opera with all that wild fury about the oak tree, the trumpet, the Siegfried motif, the great *I am*. Winifred Wagner reports that when Hitler made his first journey to Bayreuth in 1923, "he visited the Master's grave alone, and came back in a state of great emotion, saying, 'Out of *Parsifal* I make a religion.'" Hitler himself claimed that during his years in Vienna he attended thirty or forty performances of *Tristan und Isolde*, probably a heavy diet for anyone. Most historians—if they have musical proclivities—appear to be Mozart or Beethoven enthusiasts. But Wagner was not a musical fraud. He was, and is, a composer of consequence, and his position in the classical repertoire is secure. In addition, Hitler was fond of Weber's *Freischütz*, Puccini's *La Bohème*,

Verdi's *Aïda*, and some of Richard Strauss's operas, and, until the battle for Stalingrad in the winter of 1942–43, he spent many evenings listening to gramophone concerts of the music of Bruckner, Liszt, Hugo Wolf, and Johann Strauss. Moreover, one could ask: What were the classical music favorites of Stanley Baldwin or Herbert Hoover? It is frequently said that Hitler's interest in the cowboy novels of Karl May (an interest shown by many Germans, including Hermann Hesse) indicated a lack of character and thus an adolescent response to life. Perhaps so. But Dwight Eisenhower was also an avid reader of cowboy stories, while Franklin Roosevelt and countless others have been addicted to that equally innocuous and intoxicating literary genre, the detective mystery.

The longer one contemplates Hitler's intellectual and aesthetic attitudes, the more one becomes aware that much of his thought upon numerous subjects reflected, in an exaggerated and contorted fashion, so-called respectable ideas in Germany and elsewhere in Europe. George Mosse, Fritz Stern, and a number of other scholars have pointed out that an important part of German historical thinking had become in the twentieth century a potpourri of spirituality and gluttony, philosophical flights of fancy and wanton ignorance, what has been described as "a harmonious blend of the madonna and the harlot," careless generalizations and heart-rending pedantry. There was a great sweating and straining in search of the true God, the true end of history, the true society, the true German, true art. As Günter Grass showed so well in *Cat and Mouse*, German thought upon many subjects had become stained with such high-sounding but stale phrases as "Those-who-come-after-us," "And-in-this-hour," "When-the-traveller-returns," "But-this-time-the-homeland," "To-conclude-with-the-words-of-Schiller," and "The-laurel-never-will-you-take."

Evidence of this intellectual confusion—if not worse—is everywhere. A primitive social Darwinism, support for a science of amoral power politics, was rife among German philosophers, historians, and poets. The glories of the field, the forest, and the snow-capped mountains were continually and simplistically contrasted with the ugliness of the contemporary metropolis, and *Gemeinschaft* (the traditional, homogeneous, inward-looking, folk community) was persistently contrasted with *Gesellschaft* (the modern, heterogeneous, individualistically oriented society), and inevitably to the detriment of *Gesellschaft*. Well-known German intellectuals called for the restoration of a Caesarlike heroism to German life. An academic

ethnologist was on the search for the original primitive man who
would serve as a model in ridding the world of modern corruption,
while a recognized authority on ecclesiastical law at Leipzig Univer-
sity announced the amazing discovery that in the primeval forests of
Germany there were no Jews. A leading German sociologist, in a
much-quoted address, pointed out that it was the duty of Germans
not to clamor for happiness or freedom but to insure the upbreeding
(Emporzüchtung) of the national character, and a popular political
scientist advanced the argument that the law of German politics
should be: Let them hate us, as long as they fear us. Any student
who has even superficially examined what passed for historical
speculation in Germany in the first three decades of the twentieth
century must agree with Harold Rosenberg, who, in *Discovering the
Present*, remarks: "Only in Germany did the academic counter-
revolution reveal itself in the full range of its tasteless and content-
less grandeur, from man-gods to striptease genetical specimens, as
the deadly foe of modern art, the modern world, and life itself."[28]

This thinly disguised anti-Semitism, this spurious profun-
dity that masked a desperate call for action, this unfounded specula-
tion that passed for scientific objectivity, this determination to show
that tough thought and tough words were signs of historical rele-
vance—these features of much of German intellectual life appeared
in Hitler in a simplified and brutalized form. Hitler translated dis-
creet racial innuendos into racial pornography, sly remarks about
France's historical decline into attacks upon the "negrified" French,
and learned and ponderous books about how Germany should have
been successful in World War I into the shrill cry of the stab in the
back. Hitler's *Mein Kampf* was, in many respects, a distorted but
recognizable reflection of more respectable scholarship. The heated
confusion of disordered ideas, a surprising amount of random
knowledge, a fatiguing turgidity, and a stunning historical egocen-
trism—these are the identifiable properties of Hitler's autobiog-
raphy. They are often, differing only in degree, characteristics of
the writing of many of those accepted as reputable journalists, polit-
ical scientists, literary critics, and university lecturers.

There has been a tendency to argue that Hitler was
motivated by an uncontrollable urge to power, by a wild and nega-
tive destructiveness. Yet, as Eberhard Jäckel, in *Hitler's Wel-
tanschauung*, Friedrich Heer, in *Der Glaube des Adolf Hitler*, and others
have convincingly shown, Hitler did have a consistent, even power-

ful interpretation of twentieth-century European history. In order to understand him, we should take seriously his statement in *Mein Kampf* that, "Any attempt to combat a philosophy by methods of violence will fail in the end, unless the fight takes the form of an attack for a new spiritual attitude."[29] He did regard himself as a historical agent, one stimulated by a sense of historical task, with an awareness of historical time and historical place. He believed that a person without a sense of history was similar to a person without a face, and he argued that to play an important role one must be both a "programmatic thinker" and a "political leader." There must be a melding of thought and action if any meaningful response were to be made to the historical challenge of the times.

Hitler's historical interpretation, like his aesthetic program, was based upon his belief that Europe, as he conceived of it, was threatened with extinction as an important influence on this planet. According to him, the crisis of the twentieth century resulted from the fact that the great sustaining supports of European culture—the healthy, racial communities—were breaking down. Racial mixing, international intrigues, and an undisciplined individualism had brought Europe to the edge of disintegration, and the capitalist West worked in concert with the communist East to destroy the European spirit. Hitler often pointed out to his followers that the European way of life was being sacrificed to financial speculation, banks, stock exchanges, interest, dividends, liberalism, cosmopolitanism, intellectualism, Marxism, Bolshevism, rogues and thieves. He saw his task as that of restoring order to a Europe that had become disoriented, and he regarded National Socialism not only as a political movement but also as an expression of the will of Europe to save itself.

The crisis of European history had reached its advanced stages. In October 1936, in a speech at the Harvest Thanksgiving held on the Bückeberg, he said: "All of us, as we look about, see before us a threatening and a menacing world; we see unrest and insecurity, hatred and countless outbursts of human passion, yes, and of human madness, too."[30] To what could Europeans cling in such a historical storm? Not to a withered religion. Not to the shifting sands of liberal politics. Not to the empty promise of a wayward science. These only stimulated the disruptive forces that were victimizing Europeans—destroying their confidence, weakening their determination to maintain themselves as a unique part of

the human species, and promoting a sense of alienation from the roots of the European consciousness.

Hitler has correctly been described as a conservative, even a reactionary. But it is important to understand what he wished to conserve. He cared little about patterns of behavior and thought as expressed in institutions such as churches, business organizations, the military services, and what was left of the European aristocracy. In fact, these he was determined to modify or eliminate as largely useless, or even detrimental. Two things, however, were essential to the Europeans: racial identity and common cultural attitudes.

The European philosophy of race (and race was what Hitler called "the key to world history"), as it was developed in the nineteenth and early twentieth centuries, was an attempt to identify the significant characteristic that separated the Europeans from other peoples of the earth. The important racist philosophers— Joseph de Gobineau, Wilhelm Marr (who introduced the word anti-Semite into the European languages in 1879), Houston Stewart Chamberlain, Charles Maurras—believed that they had discovered the kernel of European history, the unalterable, fated, distinctive core that explained the singular European historical experience. Political movements might come and go, philosophies wax and wane, methods of production and commerce change, wars be fought, won, and lost. Such events took place in chronological time. But they were discontinuous in themselves, without ultimate meaning. Beneath the surface of human affairs was racial time, which determined the course of human history. In racial time human beings heard the call of destiny and saw themselves for what they truly were.

How does racial time express itself? Some racists believed that physical characteristics were the manifestations of racial reality and proposed various blond-hair-and-blue-eyes descriptions, cranial measurements, and even nose, hand, and feet analysis. Others saw distinctive sexual and familial practices as marks of the European race. Geography also had its advocates, and there were those who found an identity with certain parts of the earth an illustration of racial instincts. Racists with religious propensities believed that Christianity was an expression of racial inclinations and that the Christian doctrine was the result of a peculiarly racial fitness on the part of Europeans. And, of course, there were beleaguered aristo-

crats and their hangers-on who adopted an ill-defined racist outlook as a justification for defending their wealth and status.

But the most important interpretation of racism, and the one basic to Hitler's thought, was what was generally known as cultural racism. According to this point of view, what Hitler called "true people's communities" produce unique cultures which express the historical aspirations that are embodied in language, religion, ethnic connections, education, and historical memories. Every people has a specific value which is peculiar to it, and any meaningful culture is the result of a closed, integrated, homogeneous system, living by its own laws and involved in its own history. What Hitler, and others, thought of as the products of civilization—industrial techniques, commercial organizations, scientific discoveries—may be transferred from one human group to another. But cultural insights incorporating aesthetic judgments, historical understanding, and self-identification are restricted to those capable of making a racial response. Thus the true Europe was a cultural entity, an expression of a life-style, not a geographical designation. Hitler consistently argued that the simple conquest of territory was a trivial aim, and in late October 1941, with his armies anchored on the west coast of France, with Rommel's Africa Corps on the Egyptian frontier, and with German troops approaching Moscow, stated that "the power we enjoy today cannot be justified, in my eyes, except by the establishment and expansion of a mighty culture."[31]

Any culture is thus sustained by racial groupings, and racial differentiation is the basis of cultural creativity. The races of mankind may even be ranked according to cultural vitality. Some races—the Mongol, the Negro, the Malaysian—are capable of maintaining for a time a culture developed for them by others. Some national societies, such as the American, without a dominant racial definition, are devoid of any culture. One race, the Jewish, is culturally destructive. And one race, the Aryan (the Caucasian, Nordic-European gentiles), is the single, most important source of cultural activity, in reality, almost as Wagner's ash tree, holding up the world. Or, as Hitler wrote in *Mein Kampf*: "If we were to divide humanity into three groups, the founders of culture, the bearers of culture, and the destroyers of culture, only the Aryan could be considered as the representative of the first group."[32] Hitler defined

history as the presentation of the course of a people's struggle for self-preservation. Therefore, any idea or activity that endangers the racial life of the Aryans must be combatted, for, according to Hitler, in a hybridized world conceptions of the beautiful as well as all striving for an idealized future will be lost. The cultural rot, caused by the intrusion of destructive elements into European racial life, must be arrested. What he regarded as the disgusting exhibitionism of the emancipated woman, the result of alien sexual speculations, must end. The accumulation of personal wealth, which set one member of the racial community against another, must stop. Miscegenation must be outlawed. The *Asphaltliteratur*—that purveyor of anarchistic doctrines, smut, and immorality—must be silenced. Disinterested, racially neutral science must cease. In a 1937 speech Hitler said: "During the long years in which I planned the formation of the new Reich, I gave much thought to the tasks that would await us in the cultural cleansing of the people's lives."[33]

Many of the steps taken by Hitler and the Nazis to carry out this "cultural cleansing" are well known. Horrifying measures were adopted to protect the Germans from blood contamination; the Marxist movement was liquidated; and, in Hitler's opinion, the German people were freed from the plague of filthy literature. But less well known is Hitler's attack upon all forms of modern artistic expression and his attempt to impose upon Germany—and ultimately Europe—a specific aesthetic point of view. He was determined to reintroduce into art those racial and historical insights that had been lost and to make art a public expression of the unity of the Germans. Painting and sculpture were to be didactic in the sense that they were to illustrate what the society wished to inculcate and, by inference, what it wished to warn against. Art must be a refuge, even a consolation, where the Germans could find historical sustenance and discover a historical identity.

Modern art, with what Hitler called its "artistic stammerings," its "international scribblings," its "impertinent, shameless arrogance," was the opponent of the heroic, monumental, historically oriented art that he demanded. For him, modern art had no pivot, no heart, no core of inspired dignity, no clear racial definition. The trivial, the outlandish, the prosaic were being brazenly proposed as the subject matter for art, and the hubris of an unstructured and undisciplined modernity had resulted in a hysterical search for the novel, for the bizarre, for the shocking. In Nuremberg, in Septem-

ber 1935, Hitler pointed out that, "It is not the function of art to wallow in dirt for dirt's sake, never its task to paint men in the state of decomposition, to draw cretins as the symbol of motherhood, to picture hunch-backed idiots as representative of manly strength."[34] All aesthetic direction has been lost: "Sixty years ago an exhibition of so-called Dadaistic 'experience' would have seemed simply impossible, and its organizers would have ended up in the madhouse, while today they even preside over art associations."[35]

Hitler was devoted to what we must call a tribal art, and he attempted to confine German art to what he defined as the German experience, uncontaminated by distracting and confusing influences and sustained by the racial connection. Such an attitude placed him in direct opposition to modern art, which has been in the direction of a cosmopolitan awareness, and brought him inevitably into conflict with artists such as Klee, who argued that "Mankind in my work is not a species but a cosmic point." What Hitler regarded as idealistic and heroic presentations of the higher reaches of the German artistic imagination, Kirchner—undoubtedly speaking for his fellow artists—described as "pale, bloodless, lifeless slices of studio bacon." Kandinsky's statement that "The life of the spirit may be graphically represented as a large, acute-angled triangle, divided horizontally into unequal parts," could only be considered by Hitler as a piece of incomprehensible nonsense, a dangerous absurdity. Klee could claim that neither doctrines nor heresies exist in art and in a lecture of 1924 could argue that works of art do not reproduce what we see with our senses but make visible what we watch in secret, that paintings are not windows through which a viewer looks at a recognizable reality. Thus what art shows cannot be projected into life and cannot be associated with the everyday, visible world.[36] But Hitler reacted with hostility to any such contention. For him art was, and had to be, a mirror in which the reflection shows the discernible if idealistically transformed human material, and such art must relate to and be governed by the requirements of the struggle of the higher race against the lower and not by any suggestion that the creative process was the result of "inner necessity." Modern artists might claim that they possessed an independent, individualized, unique vision that gave them special and valuable insights. But Hitler would have none of such "chatter of inner experiences," none of this "Jewish-Bolshevik mockery of art," none of these "abstract scandals."

Moreover, Hitler would not accept any argument that art, as Kandinsky claimed, was a realm to itself, governed by laws applicable to it alone. Art must be part of the community, rooted in the racial realities of Germany, and thus amenable to exterior demands. Modern art had separated itself from the definitions and aspirations of the people, and artists had even argued that such separation was unavoidable. As early as 1912, Franz Marc had noted that artists were not connected with the style and needs of the general population and that modern art had arisen in defiance of the times. Thus a chasm must exist between the work of art and the public because the artist could not longer relate to the now-lost artistic instinct of the people. Schlemmer had made a similar point in a letter of 1918:

> The tremendous difference between the artist today and the artist in the past is that the artist used to be part of an entire people with its own set of values and its own religion. What a wealth of individual art works was inspired by the common ideal of Christianity! African sculpture and Greek statuary grew out of the culture of entire peoples, for whom the artist functioned as a medium, fashioning the gods and idols. But nowadays! Dilution, discarding, and destruction of old ideals. That explains the bewildering array of artistic trends and the desperate search for standards. Is it surprising that the artist of today withdraws into himself? Thus necessity attains what artists in better times earnestly aspired toward: introspection. It seems to me that this acquisition of self-knowledge provides the best justification for any artist's making himself a center and focal point; if every artist strove with utmost integrity for self-knowledge, the true source of our energy, all the many centers together would yield the whole.[37]

Such an interpretation of the place of art in the community and of the responsibility of the artist violated Hitler's sense of aesthetic and historical propriety. Klee accepted the situation whereby, as he put it, "No *Volk* supports us," but Hitler would not. Art must speak to the general society, and the society must respond to art. The artist could not be an alienated individual, separated from his people and from their history. The architect Walter Gropius wrote in 1919: "Today's artist lives in an era of dissolution, without guidance. He stands alone. The old forms are in ruins, the benumbed world is shaken up, the old human spirit is invalidated and in flux toward a new form. We float in space and cannot yet perceive the new order."[38] Hitler was convinced that he could provide the guidance,

end the flux, reinstate the old forms, and bring the artist into alliance with the people. He believed that he saw "the new order," where there would be one Reich, one people, one leader—and one art. There would be one clearly defined way for all, one expression of the German community, one law of life, in art as in politics. The problem of the lonely, searching, creative personality, a problem that had troubled some Europeans for over a hundred years, was to be solved, and Hitler was determined to excise the historical, intellectual, and even erotic anguish and confusion that he saw about him. He was thus prepared to perform what we must call a cultural lobotomy, to erase part of the European memory, and to transform the rebellious artist into a community spokesman. In 1913 Schlemmer had acknowledged that Picasso occupied a strategic position in modern art. Uninhibited by conventions, without binding allegiances to any national history, speculative, inquisitive, doubting yet assertive, Picasso was "the Hamlet of painting."[39] But there was no place in Nazi Germany for any Hamlets, for any who did not possess a positive, primarily untroubled view of the visible world. Any separation of the artist and his society would no longer be tolerated, and those painters and sculptors who could not find comfort and inspiration within the racial group were to be silenced. Art was to be restored—by Hitler the artist—to its position as the expression of those moving and noble dreams of greatness, as the apotheosis of the German spirit, as the idealistic guide in the historical task of leading the Germans out of the wasteland of modernity and into the security of the *Volk* community. And, as he said in a speech of June 14, 1938: "The world will come to Germany and convince itself that Germany has become the guardian of European culture and civilization."[40]

2

THE
VIENNESE
EXPERIENCE

"I now began to examine carefully the names of all the creators of unclean products in public artistic life."

Adolf Hitler[1]

In September 1907, the eighteen-year-old Adolf Hitler arrived in Vienna to take the examination for entrance into the General School of Painting at the Academy of Fine Arts. He had completed in the provincial Austrian towns of Fischlam, Lambach, Leonding, Linz, and Steyr the only structured education he was to receive—one of his teachers was later to describe him as "distinctly talented, if in a rather narrow sense, but he lacked self-discipline, being generally regarded as obstinate, high-handed, intransigent, and fiery-tempered"[2]—and he had, according to his own testimony, set his heart upon becoming an artist. His father was dead, his mother in Linz was mortally ill, and Hitler was, one could say, on his own.

The Academy examination was in two parts, and one hun-

dred and thirteen candidates presented themselves. The first part required applicants to perform exercises based upon such subjects as Cain and Abel, the Prodigal Son, Winter, Shipwreck, Joy and Moonlight. Thirty-three of the aspiring artists failed this part of the examination; Hitler, however, was admitted to the second phase, the presentation of "sample drawings," original work that could be evaluated by the examiners. Here Hitler did not meet the standards set, and an entry beside his name read, "Test drawing unsatisfactory." (Of the one hundred and thirteen candidates, only twenty-eight passed both parts of the examination and were admitted to the Academy.) Upon being told that his talents might lie in the field of architecture, Hitler attempted to gain entrance to the Vienna Architectural School. But he did not possess the necessary credentials for such admission. He returned to Linz. His mother died in December, and by the following February, Hitler was again in Vienna, where he took painting lessons and prepared for a second attempt to secure entrance to the Academy. The 1908 examination, however, was a disaster. He failed the first part—the section he had successfully completed in 1907—and the words "Not admitted to the test" beside his name were brutal and definitive.

The effects of this failure upon Hitler are difficult to assess, and we are left largely with suppositions, some valuable and some useless. Hitler was undoubtedly disappointed and perhaps even shamed by this turn of events. He had experienced his first serious defeat at the hands of a professional bureaucracy, and his boyhood dreams of artistic triumph had been reduced to the terrifying phrase, "Not admitted to the test." It is likely that this outcome did stimulate a latent suspicion, even hatred, of authority, and it may be that an artist scorned is an artist enraged. One possessing an artistic temperament, or who sees himself as an artist, may find it impossible to accept the adverse judgments of others or to seek fulfillment in alternative professions or occupations. Certainly there is no evidence that Hitler ever considered returning to Linz or thought of preparing himself for some other career. Rather, he decided to become an independent artist, without benefit of further training and outside the usually recognized artistic circles. He isolated himself from previous acquaintances and set out on his solitary way.

Hitler was to remain in Vienna for the next four and a half years.[3] Many details of his life during this period have been pieced together, although an absence of certain important facts still forces

us often to rely upon conjecture and careful consideration of the suspect evidence. It has been well established that those who knew Hitler for brief periods of time in Vienna, or later claimed to have known him, embellished their recollections after Hitler became famous and are, in great part, unreliable authorities. In *Mein Kampf* Hitler devotes many pages to comments upon his Viennese experience, and the book is a valuable source for understanding its author. But the autobiography, written over ten years after Hitler departed Vienna, was basically a polemic addressed to followers disheartened by the failure of the 1923 attempt to overthrow the Bavarian government. Moreover, the volume's wandering repetitions, its rhetorical excesses, and its lack of specific information raise suspicions about its reliability as an authoritative statement of actual circumstances being described. *Mein Kampf* is definitely not a "confession," an attempt to show the ambiguities, the self-doubts, the painful efforts to achieve enlightenment. Rather, it is a series of declarations, an arrogant, self-promoting exercise, a document that had other purposes than to provide an accurate and thoughtful analysis of life in Vienna. Hitler had initially planned to entitle the book *A Reckoning*, and the ultimate subtitle was *Settling Accounts*—an indication of the disputatious nature of the volume. Also, when writing *Mein Kampf*, Hitler undoubtedly ascribed many of his ideas of the early nineteen-twenties to the period when he lived in the Austrian capital, possibly because he did believe that he had arrived at certain conclusions about history and culture at an earlier date, or because the static nature of the autobiography did not stimulate any attempt to show a progression of thought but, rather, encouraged the author to state unquestioned truths that he was convinced he had been aware of during his entire adult life.

In Vienna the young Hitler drifted down into the world of flophouses, cheap meals, and the anonymity of the faceless nondescript, although he did not suffer the extreme economic deprivation that he later claimed. He was to write with excessive self-dramatization: "I, too, have been tossed around by life in the metropolis; in my skin I could feel the effects of this fate and taste them with my soul."[4] He may, as has been suggested by some students of the period, have written poems, short stories, and plays, and perhaps even the libretto for an opera that was to be patterned after Wagner's *Ring*. And he painted numerous small pictures, in oil and watercolor, at times as many as six or seven a week, pictures of the

Alter Hof, a watercolor by Hitler, Munich, 1914. From *Hitler: Legend, Myth & Reality* by Werner Maser, tr. by Peter and Betty Ross © 1971 by Bechtle Verlag. English tr. © 1973 by Penguin Books Ltd. and Harper & Row, Publishers, Inc. By permission of Harper & Row, Publishers, Inc.

Parliament building, theaters, bridges, and churches. Hilter himself states that by 1909 (he was then twenty years old) he was working independently as a draftsman and a painter of watercolors. His pictures, signed "A. Hitler," "A. H.," "Hitler Adolf," or "Hitler," were sold to dealers and others by Reinhold Hanisch, a fellow down-and-outer, with artist and agent dividing the sums received and thus supporting each other in the struggle for survival. After quarreling with Hanisch in 1910, Hitler sold his pictures through a dealer or directly to clients. He also prepared posters for merchants that served as advertisements for talcum powder, colored candles, and soap.

And he read, attended opera, concert, and theater performances, and thought about what he saw and experienced. *Mein Kampf* is replete with references to the impact of the years spent in Vienna. We read: "In this period there took shape within me a world picture and a philosophy which became the granite foundation of all my acts. In addition to what I then created, I have had to learn little; and I have had to alter nothing." And again:

> Yet Vienna was and remained for me the hardest, though most thorough, school of my life. I had set foot in this town while still a boy and I left it a man, grown quiet and grave. In it I attained the foundations for a philosophy in general and a political view in particular which later I only needed to supplement in detail, but which never left me.[5]

The Vienna of the decade preceding the outbreak of World War I has often been described as a place of gracious living, coffee houses, and sweet talk, a golden city of music, high culture, and what Stefan Zweig in *The World of Yesterday* called "epicurean" delights. The presence of the writers Arthur Schnitzler and Hugo von Hofmannsthal, the theatrical director Max Reinhardt, the composers Gustav Mahler and Arnold Schoenberg, the artists Oskar Kokoschka, Gustav Klimt, and Egon Schiele, the satirist and critic Karl Kraus, the psychologist Sigmund Freud, and the architect Adolf Loos made Vienna a city of intellectual and artistic light, a metropolis of innovative thinkers, of haunting memories, of sentiment and sentimentality, the Paris of central Europe, even a state of mind expressed in both its nostalgia and its bathos in Rudolf Sieczynski's 1913 composition *Vienna, City of My Dreams*.

Hitler did not participate in this high Viennese culture, and he was, in fact, ultimately to become the intellectual and historical

opponent of most of those associated with the glories of the city. He remained a "border Austrian," finding refuge in a shelter maintained for the homeless by a philanthropic organization and then in a men's hostel. He experienced the diseased underside of the capital, the iron brutality of squalor that was the often-ignored aspect of the last years of the Habsburg Empire. And, he later argued, he grew to hate the city. Stimulated by his solitude, by his sense of failure, perhaps by an acquaintance with examples of the gutter literature so prevalent in Vienna (in *Mein Kampf* he states that in 1909, "For a few hellers I bought the first anti-Semitic pamphlets in my life"[6]), and, perhaps again, by some personal quirk of character, Hitler developed a series of grievances that became a permanent part of his historical interpretation.

It is generally accepted that it was in Vienna that Hitler first gave any considered attention to the matter of race, and he was to write that by the end of his stay in Austria, "I had ceased to be a weak-kneed cosmopolitan and had become an anti-Semite."[7] How well developed this anti-Semitism was by 1913, the year he departed Vienna, is difficult to say. He had probably experienced erotic disgust at the thought of sexual relations between Jew and Gentile, had concluded that Marxism was a Jewish conspiracy, and had accepted the idea that Jewish commercial and financial interests played a nefarious role in European politics. But all this was rather run-of-the-mill anti-Semitism, and it is questionable whether he had yet focused his hatreds or had arrived at a consistent historical analysis. The belief that syphilis, which was endemic in Vienna and for which Hitler had a special horror, and prostitution were directly related to the presence of the Jews was a staple of the coarser strains of Viennese anti-Semitism. Hitler also unquestionably dramatized his first encounter with a Jew when he wrote: "Once, as I was strolling through the Inner City, I suddenly encountered an apparition in a black caftan and black hair locks. Is this a Jew? was my first thought." Then Hitler asked himself: "Is this a German?" Similarly, his response to the fact that a number of Viennese Jewish males were at this time marrying Gentile girls was presented in lurid and exaggerated detail: "the black-haired Jewish youth lurks in wait for the unsuspecting girl, whom he defiles with his blood, thus stealing her from her family."[8]

Hitler's hostility toward Vienna and his anti-Semitism contributed to his general cultural interpretation and to his reaction to

the new art of the twentieth century. He was to associate modernity with historical decline, and as he saw the Jew as a threat to the racial health of the community, so he looked upon modern art as a menace to the European cultural consciousness. He wrote in *Mein Kampf* that:

> One of the most obvious signs of decay in the old Reich was the slow decline of the cultural level. . . . Even before the turn of the century an element began to intrude into our art which up to that time could be regarded as entirely foreign and unknown. To be sure, even in earlier times there were occasional aberrations of taste, but such cases were rather artistic derailments, to which posterity could attribute at least a certain historical value, than products no longer of an artistic degeneration, but of a spiritual degeneration that had reached the point of destroying the spirit. In them the political collapse, which later became more visible, was culturally indicated.[9]

How many examples of modern art Hitler actually saw in Vienna is uncertain, and he was not specific as to particular painters or paintings. Rather, his condemnation was general and inclusive. Modern art, in his eyes, was a "pestilence," and, as one would expect, such art became another crime committed by the Jews: "The fact that nine-tenths of all literary filth, artistic trash, and theatrical idiocy can be set to the account of a people, constituting hardly one-hundredth of the country's inhabitants, could simply not be talked away; it was the plain truth."[10] That Hitler's facts here, even when allowing for the important part played by Jews in Viennese cultural life, were inaccurate was, of course, of little consequence to him. It was enough that "What had to be reckoned heavily against the Jews in my eyes was when I became acquainted with their activity in the press, art, literature, and the theater."[11]

But Hitler's response to modern art was much more than an expression of his anti-Semitism, important as that was. From his early twenties, he was dedicated to a heroic, monumental art that would project a clear connection of viewer and object, that would provide unambiguous guidance in the search for the true and the beautiful. He was attracted to painting and sculpture that would challenge the viewer to strive toward some lofty ideal, recapitulate historical experience, relate some tale of glorious achievement, or illustrate the harmony of the individual and the environment. Thus he rejected any meaningful contact with the crucial artistic de-

velopment that took place in Europe during the first decade and a half of the twentieth century.

In the years from 1900 to 1914 Western art was truly transformed. Meyer Schapiro has put the situation dramatically: "The world of art had never known so keen an appetite for action, a kind of militancy that gave to cultural life the quality of a revolutionary movement or the beginnings of a new religion." And he has also noted the implications of the new painting: "In the twentieth century the ideal of an imageless art of painting was realized for the first time, and the result was shocking—an arbitrary play with forms and colors that had only a vague connection with visible nature."[12] There occurred what Schapiro calls a surge toward "a boundless modernity," and the significant art of the time became identified by its choice of distinctly unheroic, contemporary figures, by its stress upon new interpretations of postures, gestures, and costumes, and by the search for novelty. Never before in European history had artists set out so consciously and so violently to change the physical appearance of their subjects, and by the time Hitler arrived in Vienna what we think of as the European modernist movement was well under way. Cézanne, Van Gogh, and Gauguin were being accepted as the new masters ("Let us talk again about Cézanne" was the refrain of a popular poem in Parisian artistic circles), and one activity after another provided evidence of startling change. The showing of the Fauves had taken place in Paris in 1905; the same year Matisse painted *Woman with a Hat*, described by Gertrude Stein's brother Leo as "a thing brilliant and powerful yet the nastiest smear of paint I have ever seen" (the Steins purchased the picture); and Picasso painted his *Les Demoiselles d'Avignon* in 1907. In 1909 Emilio Marinetti published his manifesto of Futurism; in 1910 Guillaume Apollinaire and Max Jacob initiated the French poetic movement known as surrealism, and in 1912 Marcel Duchamp completed the famous and notorious *Nude Descending a Staircase*. A series of international exhibitions—the Post-Impressionist showings in London in 1910 and 1912, the Sonderbund show in Cologne in 1912 (organized by the Federation of West German Art Lovers and Artists and containing 125 works by Van Gogh, 26 by Cézanne, 25 by Gauguin, and 16 by Picasso), and the Armory show in New York City in 1913—spread the provocative influence of French art to other parts of the world.

Vienna, too, became infected with what would be called by

traditional art critics and social commentators "the poison of modernism." In 1897 a small group of artists organized the Vienna Secession (the word had been first used in Munich earlier in the decade) in opposition to the conservative Academy of Fine Arts and its exhibition practices. Gustav Klimt, who was the most important member of the rebellious group, argued that he and his colleagues believed that it was necessary to bring artistic life in Vienna into contact with the advanced art movements from abroad and to present a purified, modern view of art. In 1898 the first Secession exhibition—which included works by Auguste Rodin, James Whistler, and Max Klinger—was held. The introduction to the catalog for the exhibition stated:

> Since the greater part of our public has until now been left in blissful ignorance of the momentous developments in art abroad, we have tried in this, our first exhibition, to present a picture of such modern art, so that the public may thus obtain a new and higher standard by which to judge Austrian art.[13]

Over 57,000 visitors attended the showings, and over two hundred paintings and pieces of sculpture were sold. In 1903 the Secession sponsored the first significant showing in Vienna of paintings by Manet, Monet, Renoir, Degas, Pissarro, Cézanne, Van Gogh, and Gauguin.

The heroic days of the Vienna Secession were over by the time Hitler settled in the city, although animosity and controversy continued to plague the art scene. In 1908 Klimt exhibited *The Three Ages of Man* and *Danaë*, which, a hostile critic remarked, invited viewers to admire her thigh and half her bosom. His *The Kiss*, a lush, exotic, sensual presentation, was also on show, as were Kokoschka's designs entitled *The Bearers of Dreams* and illustrations from his drama, *Murderer the Hope of Women*. What were called Kokoschka's "color massacres" stimulated widespread complaints, and in an extreme response Archduke Franz Ferdinand declared that the artist should have every bone in his body broken. In 1909 Egon Schiele first exhibited in the city, and in subsequent years shocked the public with his nude studies, wherein eroticism was connected with the themes of suffering and death.[14]

More important, however, than these events in Vienna were artistic activities in Germany, and there the stage was being prepared for the conflict between Hitler and the artists that was to take

place three decades later. The modernist movement had caused its initial stirrings in Germany in the eighteen-nineties (in 1897 the Berlin National Gallery was the first museum anywhere to purchase a Cézanne). In 1903 the first exhibition of the works of Van Gogh (later described by Max Pechstein as "a father to us all") took place in Berlin, and it was in the German capital that the art dealer Paul Cassirer organized showings of Cézanne in 1904 (Kaiser Wilhelm II suggested that Cassirer was "bringing garbage from Paris") and of Matisse in 1907. The content and style of German painting were given new directions, and the important artists began that metamorphosis that resulted in a new type of German art and a new definition of the German artist.[15] A brief and illuminating analysis of what occurred appeared in the painter Carl Hofer's essay "What Is German Art?" published in 1932. Hofer, in looking back at the years of his youth, pointed out that at the turn of the century there was in Germany "no school, no teacher, and, above all, no living tradition that could have transferred even the most primitive elements of the new formative arts." Thus, "it is understandable that my generation and the one following found guidance and stimulation from the great French art, from Van Gogh, and from Munch. Without these forerunners contemporary German art is unthinkable." The protective wall of the German *Volk* community was breached, and German painters and sculptors became increasingly interested in and fascinated by non-German subjects and non-German aesthetic insights, not in order to imitate but, according to Hofer, in order to translate "universal values into one's own language."[16]

The world opened to German artists, and they became citizens of the new international aesthetic community while, as it was said, remaining "thoroughly German." In 1905 Ernst Kirchner, as he expressed it, "found a parallel" to his own work in African Negro sculpture and in Oceanic beam carvings. The next year Ernst Barlach made his journey to Russia, an experience that was to have a permanent effect upon his subsequent work, alerting him to the fact that "we humans are at bottom all beggars and problematic existences," and produced his *Russian Beggar Woman*, the first of his pieces to be described later by the critic Alfred Werner as "these short, squat, round-headed, slit-eyed, flat-faced beggars, monks, pilgrims, and peasant women on the steppe." At approximately the same time Franz Marc was becoming attracted to the African and

Incan sculptures that he saw in the Berlin Ethnographical Museum, and in 1907 visited Paris, where he walked among Impressionist paintings "like a roe-deer in an enchanted forest, for which it has always yearned." Lyonel Feininger, who resided in Paris after 1906, became acquainted with the modernist movement and in 1913 wrote that he found "the art world agog with Cubism—a thing I had never heard mentioned before, but which I had intuitively striven after for years," while Pechstein had worked in France and had attended the exhibition of the Fauves in 1905. Max Beckmann, whose first significant work, *Young Men beside the Sea*, was exhibited in 1906, studied in Paris and Florence, Conrad Felixmüller in Rome, and Hofer, in addition to extended periods of study and work in Rome and Paris, made two trips to India in 1909 and 1911. In 1913–14 Emil Nolde was a member of an ethnological expedition to Russia, Japan, and New Guinea, while Pechstein in the same years made a journey to the Palau Islands in the south Pacific, and the effect of these voyages can be seen in the paintings done by both artists upon their return. In the spring of 1914 Paul Klee and August Macke made a short trip to North Africa, and Klee announced upon his return to Germany that "Color and I are one. I am a painter."

But German artists were more than mere travelers and observers. Although never a unified group, they became active participants in the modernist movement and succeeded in freeing German art from the idealism, heroism, Romanticism, and historical speculation that had plagued it throughout the greater part of the nineteenth century. In 1905 in Dresden, Kirchner, Erich Heckel, Fritz Bleyl, and Karl Schmidt-Rottluff united in a loose organization known as *Die Brücke* (the Bridge), a word conveying the idea that the work of painters in a German provincial city was connected to the new, outside world of art. For eight years, in Dresden and then in Berlin, the group (which was also to include Pechstein, Otto Mueller, and, for a time, Nolde) sponsored exhibitions and provided a rallying point for artists striving for a new focus for their work. In Munich, where the first showings in Germany of the paintings of Picasso and Braque took place in 1909, the New Artists' Association, dedicated to the promotion of contemporary art, was founded, Then, in 1911, the first *Blaue Reiter* (Blue Rider) exhibition was held, to be followed in 1912 by publication of *The Blue Rider Almanac*, which was edited by Kandinsky and Marc. The almanac was described by its supporters as "the organ of all the new and genuine ideas of our day," and

contained reproductions of works by Picasso, Macke, Kirchner, Robert Delaunay, Matisse, Pechstein, and Kokoschka, the scores of musical compositions by Schoenberg, and pictures of artifacts from Brazil, the Easter Islands, Mexico, New Caledonia, Alaska, Egypt, and the Marquesas. Kandinsky's *Improvisation No. 27* and Kirchner's *The Inn Garden* were on exhibit at the New York Armory Show, as were Wilhelm Lehmbruck's *Young Girl*, which sold there for $1,620, the highest price paid for a piece of sculpture at the exhibition, and his *Kneeling Woman*, which, priced at $2,160, did not sell and about which Theodore Roosevelt made the unfortunate comment that "though obviously mammalian it is not especially human."

Individual German artists were developing their distinctive styles in their attempts, as Kirchner noted, to find means of giving pictorial form to contemporary life. Käthe Kollwitz, who had first exhibited in 1893 and had achieved her initial important recognition in 1898 with her *Weavers* prints, in 1903 completed the series on the *Peasants' War*. Barlach, who had, according to his own testimony, developed a spiritual kinship with the suffering, simple, hoping, searching, and hence vice-ridden beings given to drink, song, and music, in 1907–08 produced his first wood sculptures, *Sitting Woman*, *Sitting Shepherd*, and *Shepherd in a Storm*. In 1909, in his *Resurrection*, Beckmann introduced the incongruities and the tensions that were to characterize his important subsequent work. We see the rising dead in company with men and women in fashionable dress, the event taking place in the midst of a drawing-room conversation in which Beckmann himself appears, calmly smoking a cigarette, while his mother-in-law looks on placidly, as if awaiting a mysterious call from some off-stage director. In that same year Nolde completed *The Last Supper*, the most dramatic and controversial of the paintings making up his religious cycle (in 1910 the painting was purchased for the museum in Halle, the first Expressionist picture bought for a German public museum). Mueller was at work upon his two-dimensional nudes and Kirchner upon his collection of artist's models, streetwalkers, dancers, and circus performers. In 1911 Klee prepared his illustrations for Voltaire's *Candide;* while in 1913 Marc incorporated Cubism and Futurism into his *Fate of Animals*, that apocalyptic vision with a blue deer, red foxes, and green horses; and Oskar Schlemmer and his brother opened the first gallery in Stuttgart to exhibit modern German and non-German painting. A Cologne newspaper, in 1911, printed a review of work on show in

Düsseldorf by the Bridge group, and the reviewer, in an ill-tempered and contorted manner, indicated at least a faint awareness of what was happening to German art:

> The term "Bridge" probably is meant to declare that here we have a union of German and French art. The majority of the pictures shown belong to the Neo-French movement which was imported to Düsseldorf by Russians living in Munich. . . . The utter worthlessness of the drawing in these paintings is unsurpassable; they are nothing but games played with shouting colors by a group of cannibals. If viewed as paintings, they are the end of all art, a gross misdemeanor, but they show an aspect that is even more evil. The modern thought that the object of art is of no importance is here maliciously misapplied. Even last year we remarked in the face of these Russians that they portray an infamous concept of women in their paintings. This applies even more to the German artists. What we are shown reeks of pestilence from the darkest recesses of vice of some big city and reveals these artists to be in a state of mind which can only have a pathological explanation. [17]

An explosion of words also took place in Germany as artists, as well as those art critics supporting them, attempted to explain the German relationship with and to identify the German contribution to the new European art movement. Julius Meier-Graefe, who had founded the review *Pan* in the eighteen-nineties and was instrumental in introducing Manet and other French artists to the German public, in 1904 published his *The Development of Modern Art*, which has been described as the first modern history of modern art. In 1907 Wilhelm Worringer published *Abstraction and Empathy*, an influential argument that the direction of modern art was toward the geometrical and the abstract. Matisse's *Notes of a Painter*, which contained the claim that forms in modern painting were primarily free-flowing, linear arrangements and that colors need have no descriptive function, was immediately printed in German translation following its initial publication in 1908. From 1910 to 1914 in Berlin Herwarth Walden's literary magazine *Der Sturm* vigorously supported the international art movement, and Walden became a confidant of Delaunay (Klee's translation of Delaunay's essay on the function of light in painting was published in *Der Sturm* in January 1913), Apollinaire, Marc Chagall, Kokoschka, and others. The weekly *Die Aktion*, also published in Berlin and edited by Franz Pfemfert (who stated, "I established this journal against the face of the age"), was a true avant-garde periodical and provided critical support and an

outlet for reproductions of work by Kirchner, Marc, and Schmidt-
Rottluff.

Kandinsky published *Concerning the Spiritual in Art* in 1911
and also underwent what he called "an unexpectedly bewitching
experience"—an awareness of shape and color but incomprehensible
content—and posed what he regarded as the most important ques-
tion of modern art: "What was to replace the missing subject?" In
1912 Beckmann and Marc carried on a debate in print over the
nature of color in modern painting and the relationship of the surface
of a painting to the inner meaning. Later, Beckmann was to put his
argument in a sentence—"I want a style that, in contrast to the art of
exterior decoration, will penetrate as much as possible into the fun-
damentals of nature, into the soul of things"—and Marc incor-
porated into a series of aphorisms such thoughts as, "Our European
desire for abstract form is nothing other than the highly conscious,
action-hungry determination to overcome sentimentality" and "Tra-
ditions are lovely things—to create traditions, that is, not to live off
them," as well as proposing an artistic approach that "will have
changed the old fables of the world into a general principle of form,
and transformed the old philosophy, which looks at the outside of
the world, into another that looks into it and beyond."[18] This intel-
lectual interest was noted by an English critic, who, in attacking the
London exhibition of Post-Impressionists in 1912, complained that
the Germans "are eager for all the arts. Denied almost entirely an
instinct for the art of painting, they study it, they 'encourage it,' egg
it on, adore, and even buy." In addition, "to their serious bosoms
they have taken each extravagance of Montmartre and added an
'ismus' to its name."[19]

Locked in his own thoughts and in his limiting environment,
Hitler did not participate in any of this argument over the use of
color, the nature of the subject, the new ideas about light and shade,
the pressing upon the outer edges of artistic perception. Klee's
diaries of the first two decades of this century have provided us with
an awesome account of the speculations of a modern creative con-
sciousness, an insight into an artist who was attempting "to build
modestly, like a self-taught man," who found that the "thought of
having to live in an epigonic age is almost unbearable," and who
sensed that "a great moment has arrived, and I hail those who are
working toward the impending reformation."[20] But Hitler was no
traveler, geographically or intellectually; he corresponded with no
fellow artists, and he took no part in any fruitful if interminable

discussion about the meaning of artistic creativity. It is unlikely that he read any of the important documents on modern art that appeared while he was in Vienna, and his own art illustrates his failure to participate in the modernist experience. Watercolors such as *Auersperg Palais* and *Karlskirche* are true examples of inferior "postcard" art—dated, stiff, and with little to commend them save the curiosity aroused by our knowledge of their creator. In *Hitler's Youth*, Franz Jetzinger argues that Hitler's Viennese drawings and paintings are not original, but copies, and claims that Hitler did not draw from life. More important, there is no life in the work, and these buildings, parks, and monuments are stale and stilted. One need only compare Hitler's pictures with Schmidt-Rottluff's *Berlin Street* and Kirchner's *Tramlines in Dresden*, both painted in 1909, or with Nolde's 1910 etchings of Hamburg, with, as has been said, their "noise and uproar, tumult and smoke and life," to see immediately the gulf separating Hitler's approach from that of the modernists. And anything such as Heckel's 1913 *Glassy Day* or Kirchner's *Five Women in the Street* of the same year was absolutely beyond Hitler.

Art critics commonly argue that "deciphering" the paintings of Picasso and Braque at this time was similar to attempting to understand a foreign language through a few unrelated words. But Hitler's art requires no "deciphering." It suggests no contact with the intellectual and creative adventure that was modern art, and we are not confronted with any problem of moving time or changing spatial relations. Some of the efforts he was to make during World War I—the sketch *Dugout at Fournes*, the watercolor *Haubourdin*, the pen-and-wash drawing of German infantrymen playing draughts in a trench—and the 1913 oil painting *Schliersee* are not too dissimilar to some of the work being undertaken by now-recognized German artists in 1900 and compare well with the attempts of other politician-painters such as Winston Churchill and Dwight Eisenhower. But Hitler was already a dozen years out of date, and he was to remain impervious to that turbulent artistic ferment of the early years of the century. His perception remained imprisoned in the stiff and monumental formalism that appears in his Viennese paintings and was to be characteristic of his prewar Munich watercolors such as *Alter Hof* and *Feldherrnhalle*. Whatever may have been Hitler's possibilities as an artist—and some, such as the theatrical producer Gordon Craig and the historian Werner Maser, have seen potential in the early work—he did not capitalize upon them.

Kirchner, Beckmann, Pechstein, Marc, Macke, Heckel, Schlemmer, Schmidt-Rottluff—and Hitler—were born in the eighteen-eighties. But they were contemporaries only in a simple, chronological sense. They were to see different realities, respond to different aesthetic imperatives, and pledge their loyalties to different interpretations of the human situation. Beckmann believed that he could only speak with people who already carried within them a similar metaphysical code. And Hitler's metaphysical code, formed by his temperament and his experiences, made impossible any sympathetic response to modern art or modern artists. A friend once wrote that Macke had an insatiable curiosity for life, and Marc admitted that he made the most outrageous demands upon his imagination. But Hitler's road stretched in another direction, ultimately toward the supposed security of the organized human spirit, toward the confining of what was called Klee's "limitless fancy," toward the dream of the master builder wherein racial memories and racial aspirations were to be incorporated into the artistic expression of the frozen model that would, he believed, provide Europe with its aesthetic standard for the next millennium.

In May 1913 Adolf Hitler left Vienna for Munich. Upon his arrival in the Bavarian city, he registered with the police as a "painter and writer." Bradley F. Smith writes that Hitler at this time was "still chasing the will-o'-the-wisp of an artist's life."[21] But it may be that as he left Vienna Hitler was drifting and realized that he was not going to become a great artist. He continued to paint and to read in Munich, but he wrote in January 1914, "I earn my living as a self-employed artist, but I do so only in order to continue my education, being otherwise quite without means. I can only devote a very small part of my time to earning as I am still learning to be an architectural painter."[22] He was to retain throughout his life an interest in art and was to treasure what he regarded as his unique artistic insights. But historical circumstances were to open new possibilities, and war, social disorder, and historical confusion were to carry him away from the artist's career. As Hitler noted in *Mein Kampf*, and undoubtedly in reference to himself:

> In the monotony of everyday life even significant men often seem insignificant, hardly rising above the average of their environment; as soon, however, as they are approached by a situation in which others lose hope or go astray, the genius rises manifestly from the inconspicuous average child, not seldom to the amazement of all those who had hitherto seen him in the pettiness of bourgeois life.[23]

3

IN MUNICH
WITH
DIETRICH ECKART

"We've all taken a step forward on the road to existence, and we can no longer picture to ourselves what Dietrich Eckart was for us. He shone in our eyes like the polar star. What others wrote was so flat. When he admonished someone, it was with so much wit. At the time, I was intellectually a child still on the bottle."

Adolf Hitler[1]

The Blue Rider group held its last exhibition in 1912, and the Bridge, strained by disputes among its members, dissolved the next year. By this date, however, the important German painters and sculptors were established artists. Franz Marc had completed *Tower of Blue Horses* and *Fate of Animals*, Ernst Kirchner *Red Tree on a Beach* and *Street Scene*, and August Macke *Woman in Green Jacket* and *The Hat Store*. In 1912 the first American exhibition of the works of Käthe Kollwitz was held in New York City, and a year later the first

47

major descriptive catalog of her graphics was published in Berlin. The art dealer Paul Cassirer presented the first retrospective of the works of Max Beckmann, and in 1913 Herwarth Walden sponsored the first German Salon of Autumn, where three hundred and sixty-six paintings by Marc, Macke, Lyonel Feininger, Marc Chagall (his first public showing), Max Ernst, Piet Mondrian, and Hans Arp were viewed by large and enthusiastic crowds.

But there was little time to savor these triumphs. The First World War interrupted the careers, as it changed the lives, of almost all of the artists associated with the modernist movement. Two of the most talented painters were killed—Macke at the Marne in 1914 and Marc near Verdun in 1916—while Wilhelm Morgner disappeared during a battle on the western front in 1917. Others were seriously scarred by their military experiences. Beckmann served as a medical corpsman until he suffered a nervous breakdown; Otto Dix was several times wounded; George Grosz was released from the army after a series of severe illnesses; and Kirchner was struck by a mental collapse, the results of which were to trouble him for the remainder of his life. Heinrich Ehmsen was stationed in France and Rumania; Otto Freundlich was in the medical corps; Erich Heckel spent the war years in Flanders; Paul Klee was a member of a unit escorting military transport; Ludwig Meidner was an interpreter in a prison camp; Max Pechstein served in France, Karl Schmidt-Rottluff on the eastern front, and Heinrich Vogeler in Poland, Rumania, and France.

The influence of the war and its aftermath can be seen in much of the subsequent work of German artists, the great majority of whom became confirmed pacifists, or, as ultranationalists were to complain, "defeatists." In subject and tone, painting and sculpture illustrated the violence and disorder introduced into German life by the events of 1914–18 and indicated the efforts of artists to confront personal and historical experiences that appeared to have, in Klee's words, "about as much sense as a wad of dung on a shoe heel."[2] As early as 1915, Kirchner had painted his *Self-Portrait as a Soldier*, where he showed himself as an emaciated, exhausted, uniformed figure, with a green stump for a right hand, a verification of Klee's later remark that broken and mutilated creatures are best rendered by their own debris. Kollwitz, whose son had been killed in Flanders, used the war as a theme for a large number of works, culminating in her *Never Again War*, and Dix, in 1924, issued his *War*, a

series of fifty etchings illustrating the horrors of military combat. Grosz made his savage attacks upon the military establishment, the most notorious of which was his *Christ with Gas Mask*, where a forlorn Jesus hangs on the cross, largely naked except for the mask and army boots, while Beckmann's canvases of the nineteen-twenties were continual reminders of the disasters associated with war, filled with maimed bodies, pimps and prostitutes, shabby carnival scenes, and nocturnal crimes. Perhaps the most dramatic comments upon the war were by Ernst Barlach. In 1928 he completed the war memorial for the cathedral at Güstrow ("The angel of the Güstrow memorial overwhelmed me," remarked Bertolt Brecht), and in 1929 the Magdeburg memorial, where six alienated figures stand in two ranks about a rough cross upon which are inscribed the years 1914, 1915, 1916, 1917, 1918. Here are pathetic, broken men, one with a piece of cloth thrown over his face, another holding his head, all lost souls in some lost world, separated from other human beings and from each other by experiences beyond rational explanation.

Prior to World War I, artists had been politically inactive, although they appeared to some as dangerous radicals because of their rejection of many of the standards of stolid, prosperous, Imperial Germany. The subject matter and the style of their art—with its criticism of aristocratic and middle-class life—set the important painters and sculptors at odds with prewar society. Barlach portrayed suffering and impoverished individuals, while much of the work of Kollwitz could be regarded as an extended commentary upon her *Pictures of Misery* of 1909. A predilection for using bordellos and dance halls as themes for paintings and the pictorial expression of a threatening even sinister sexuality by Kirchner, Heckel, and others indicated a rejection of middle-class propriety and aroused the anger of those Germans who realized that their social and domestic values were being caricatured. Modern German art, with its fragmented images, its apparently disordered landscapes, and its suggestions of violence, expressed opposition to many of the common institutional patterns of Germany, and some artists, particularly Franz Marc in paintings such as *Fate of Animals*, projected an approaching catastrophe.

In the confusion and upheaval following the armistice of November 1918, many painters and sculptors became involved in radical activities and adopted a left-wing stance. They signed

Dietrich Eckart in 1921. Reprinted from Margareta Plewnia, *Auf dem Weg zu Hitler. Der "völkische" Publizist Dietrich Eckart* (Bremen: Carl Ed. Schünemann, 1970).

numerous manifestos calling for the emancipation of the working classes, for the end of all human exploitation, and for the creation of a new society. Pechstein, Feininger, Freundlich, Heckel, Meidner, Heinrich Campendonk, and Schmidt-Rottluff were associated with the Berlin Workers Council for Art, an organization patterned after

the Soldiers and Workers Councils so common at the time. In December 1918 Pechstein (who later stated, "I had no hesitation in putting myself at the disposal of the Social Democratic government") joined Freundlich, Rudolf Belling, Conrad Felixmüller, and others in an artists' November Group, which issued appeals for creative individuals to play socially conscious roles in postwar Germany. Feininger, Felixmüller, Pechstein, and Schmidt-Rottluff contributed illustrations to the ultra-left, socialist magazine *Die rote Erde* (The Red Earth), published in Hamburg. In May 1918 Felixmüller published a woodcut *Long Live World Revolution* in the Berlin revolutionary newspaper *Die Aktion* (Action), and in January 1919 Meidner published a manifesto, *To All Artists*, the cover of which displayed a drawing by Pechstein showing a worker with a flaming red heart, set against a city skyline, with a raised hand as an appeal to artists to join in a common struggle. Beckmann, Heckel, Pechstein, and Schmidt-Rottluff supported radical Berlin newspapers; Feininger did a woodcut, *Cathedral of Socialism*, which appeared as the frontispiece to the first Bauhaus manifesto of 1919; while Dix and Grosz were members of the Red Group in Berlin, an association of artists, writers, and assorted intellectuals pledged to ultraradical politics.[3]

But such political commitments were not sustained during the nineteen-twenties. Vogeler joined the German communist party and was to remain a steady supporter of the communist cause, settling in the Soviet Union in 1931, while Dix, Felixmüller, Pechstein, Freundlich, and Grosz continued their allegiance to political radicalism, with artistic assaults upon the military and business leadership of Germany and with predictions of the imminent collapse of the middle class. Kollwitz, who in 1920 produced the famous woodcut *Memorial for Karl Liebknecht*, remained dedicated to social democratic principles, and her work was an artistic comment upon historical events. The November Group survived throughout the decade but in anemic condition. The majority of the artists, however, found themselves unsuited for the turbulence and confusion of political life, and while they generally retained sympathy for liberal causes, they avoided consistent engagement in political activities. Feininger described organized politics as "the worst of devilment," and as early as 1922 Beckmann completed a lithograph entitled *Disillusioned*, which suggested the boredom artists experienced when confronting the works of Marx, Liebknecht, and Rosa Luxemburg. Later, in the nineteen-thirties, he was to write that "Politics is a

subaltern matter whose manifestation changes continually with the whims of the masses, just as cocottes manage to react according to the needs of the male and to transform and mask themselves."[4] Although the Nazis were to refer to the Bauhaus as the "Synagogue of Marxism," those artists identified with the institution—Kandinsky, Klee, and Oskar Schlemmer—were without strong political affiliations and took little interest in general political affairs. The important artists remained antimilitaristic and antiwar, and with the exception of Emil Nolde, who was a charter member of the North Schleswig branch of the Nazi party, showed little sympathy at any time with the Nazi program. They deepened their international and cosmopolitan insights and inclinations and, again with the exception of Nolde, indicated no evidence of the stain of anti-Semitism.[5]

Political activity was, of course, largely irrelevant to the careers of the artists, and in spite of wartime experiences and the turmoil of German life in the nineteen-twenties the postwar period was a time of notable accomplishment. The modern German artistic flower truly opened. Klee, it was said, appeared to flourish like a tropical plant, and became a leading figure in the art world with works such as *Puppet Show*, *Landscape with Yellow Birds*, and *Flagged Town*. The first exhibition of his paintings in the United States was held in New York in 1924, and in the next year he participated in the initial exhibition of surrealist painters in Paris in company with Arp, de Chirico, Max Ernst, Miro, and Picasso. Barlach's wood sculptures became popular with collectors, and a 1926 exhibition in Berlin, which included *The Dreamer* and *The Reunion*, was a critical and financial success. The decade also saw the appearance of Otto Mueller's *Blue Nudes*, of Feininger's *Gateway Tower*, of Nolde's north German landscapes, of Beckmann's *The Dream, Pierrette and Clown*, and *The Boat*.

By 1932 Carl Hofer could claim: "We are today the only nation whose art as a whole can stand up next to the French. Not through an attempt to present our nature in national specialties, but on the higher plateau of universal forms in art."[6] Many artists were successful in finding positions in Germany's prestigious art schools: Hofer in Berlin, Mueller in Dresden, Heinrich Campendonk in Essen, Beckmann in Frankfurt, and Dix in Dresden. Barlach, Christian Rohlfs, Pechstein, Nolde, Schmidt-Rottluff, and Kirchner were elected to membership in the Prussian Academy of Arts, as was

Kollwitz, the first woman to be so honored. In 1919 a modern section of the Berlin National Gallery (the first museum in Europe devoted specifically to the collection of modern art) had been established, and among the initial works acquired were Marc's *Tower of Blue Horses*, Kirchner's *The Street*, Heckel's *Ostend Madonna*, and Barlach's *The Deserted*. Other public galleries followed the Berlin example, while private collectors engaged in widespread purchase of modern works.

It was late November 1918 when Adolf Hitler returned from wartime service to Bavaria and shortly thereafter to Munich. He had greeted the outbreak of war enthusiastically ("I fell down on my knees and thanked Heaven for granting me the good fortune of being permitted to live at this time"),[7] and from October 1914 to October 1918 he had been almost continually involved in military campaigns on the western front. He had fought at Ypres, in Flanders, on the Somme, at the Marne, and at Soissons. He had been wounded and gassed and had been awarded the Military Service Cross Third Class, the Iron Cross Second Class, and the Iron Cross First Class. Now, at war's end, he had no family, no influential friends, no profession, and no prospects. Yet during the next five years he was to establish the basis for his political career. He developed his amazing talent for oratory. He began the transformation of a small group of undistinguished, discontented men into a mass political party over which he would exercise unquestioned authority. He survived—one could even say mastered—turbulent, near-criminal surroundings and learned how to use to his advantage brawlers, jailbirds, psychopaths, and other "irreconcilables."

Life in Munich in the early nineteen-twenties was hectic, desperate, and dangerous. The city experienced one political shock after another and became a haven for the economically, intellectually, and culturally dispossessed. Displaced aristocrats, army officers turned adventurers, reactionary German exiles from the Baltic lands—the most reckless and lawless of those with a grudge against postwar Europe—settled in Munich. Here were sadists and murderers such as Gerhard Rossbach, political swashbucklers such as Vassily Biskupsky, members of the Thule Society who were to be implicated in a number of political assassinations, the Russian refugees responsible for the first German translation of *The Protocols of the Elders of Zion*, who in 1920 moved from Berlin to Munich, and supporters of General Erich Ludendorff, who engaged in various

Nazi party day on January 28, 1923. Eckart is standing directly behind Hitler. The man walking to the right and looking at the camera is Alfred Rosenberg. Reprinted from Margareta Plewnia, *Auf dem Weg zu Hitler. Der "völkische" Publizist Dietrich Eckart* (Bremen: Carl Ed. Schünemann, 1970).

conspiratorial activities and published superpatriotic provocations under such titles as *Judaism and Freemasonry* and *At the Sacred Fount of German Might.*

It was in this feverish environment that Hitler's philosophy took form. Whatever may have been the permanent influences of his experiences in Vienna, the traumatic events of the years after 1914 brought about circumstances far more burning than those of the troubled but still relatively stable prewar Austria and forced him to attempt a full-blown historical analysis. The defeat of Germany, the communist revolution in Russia, the disgrace of the Versailles peace treaty, the short-lived Soviet government in Bavaria—these catastrophes far transcended the frustrations of Viennese days. The years from 1918 to 1923 were crucial. Although subsequent events did require Hitler to modify some of his attitudes, temporarily and for reasons of political strategy, the bedrock of his historical interpretation had been established by the middle nineteen-twenties.

It would be foolish to identify a single source for Hitler's ideas or a single influence in Munich. But in respect to his attitudes toward art and general European culture, one person did play a significant role. This was Dietrich Eckart, poet, playwright, journalist, twenty-one years older than Hitler, and now remembered—if at all—primarily for his translation of Henrik Ibsen's *Peer Gynt* into German. Hitler the loner—as a boy, as a struggling artist, as a soldier—found in Eckart an intellectual confidant, a man of ideas and of "vision." The friendship of the two was undoubtedly genuine. Throughout his life, Hitler was notoriously silent about acknowledging his intellectual and political debts, and he had at best an indifferent and grudging allegiance to most of those who thought of themselves as his comrades. But his regard for Eckart never faltered. *Mein Kampf* concludes with a tribute to Eckart, and Hitler was fond of citing Eckart as an authority, as when, during a conversation on the night of December 1–2, 1941, he stated: "Dietrich Eckart once told me that in all his life he had known just one good Jew: Otto Weininger, who killed himself on the day when he realized that the Jews lived upon the decay of peoples."[8] In October 1933 Hitler delivered a laudatory address on the occasion of the dedication of a monument to Eckart in Neumarkt, and the gymnastic events at the 1936 Berlin Olympic Games were held in the Dietrich Eckart Stadium, a newly built structure that was designed as a permanent memorial to Eckart. As late as 1942, when speaking at his headquar-

ters on the Russian front with military officers who probably had
only the vaguest idea of Eckart's identity, Hitler reflected upon his
years in Munich and remarked nostalgically: "How I loved going to
see Dietrich Eckart in his apartment. What a wonderful atmosphere
was in his home."[9]

By the time he met Hitler, Dietrich Eckart was a person of
some reputation in nationalist and anti-Semitic circles.[10] Born in
1868 in Neumarkt, Eckart moved to Berlin in 1899. He lived in the
German capital as an intellectual adventurer, described by one of his
biographers as a "wanderer on the streets of life." He considered a
career as a lawyer, but, according to Hitler, abandoned the idea "so
as not to become a perfect imbecile." As a result of a serious illness in
the eighteen-nineties, he had become addicted to morphine, to what
he called "the sweet gift," and he scratched a living by incidental
journalism and whatever came to hand. He had published a book of
poetry in 1893, a collection of lyrics that spoke of the anguish of
love, the song of the nightingale, summer nights, and such staples of
the romantic verse of the times. In Berlin he wrote plays—ten dur-
ing the next fifteen years—and began a novel (never completed), to
be entitled *The Morning*, in which the central character was to be
drawn from Eckart's own experiences. Like the Marquis de Sade, he
even staged plays in an insane asylum, using inmates as actors and
actresses. In 1914 he finally achieved recognition with the theatrical
production of his translation of *Peer Gynt*. Eckart had labored for
three years on the project, and he attempted to transform Ibsen's
drama into a Faustian treatment of the German search for identity
and self-knowledge. The play was a financial and critical success,
receiving favorable reviews in over eighty of Germany's leading
newspapers, and was the second most popular play in Germany
from 1914 to 1918, as measured by the number of performances.

In 1915 Eckart moved to Munich. He now became involved
in patriotic writing and began to color his nationalism with anti-
Semitic preachments. He contributed to numerous newspapers and
magazines and in December 1916 published an important if unori-
ginal essay entitled "Thoughts on the Chaos of Our Time." Here he
attacked materialism, spiritual confusion, and the tendency of Ger-
mans to abandon their traditional folk attitudes for popular cliches
such as "freedom" and "humanity." He described himself as one
engaged in a struggle with "the trolls," that ragtag collection of
"unbelieving, empty, modern men," who threatened to break out

from underground and destroy German culture. As a friendly biographer wrote, Eckart's "combative soul now stood against the chaos like an eternal rock."

The German defeat in World War I had a shattering effect upon Eckart. He reacted to this disaster by becoming a violent chauvinist, an obscene pamphleteer, and a well-known "Jew-eater." (The phrase describing Eckart was usually given as *ein Judenfresser*, thus stressing the distinction between the German verbs *essen*, depicting the eating by human beings, and *fressen*, the cruder, more voracious eating by animals.) His poetry became an incitement to anti-Semitic action, as did a series of brochures he published in the years immediately following the end of the war: *Austria under Judah's Star, That Is the Jew, Judaism in and out of Us,* and *Gravediggers of Russia*—the last also appeared in English, Russian, Polish, and Czech translations. (When Eckart sent a copy of *That Is the Jew* to an unidentified German professor, the pamphlet was returned with a note stating that it was full of hate. Eckart responded: "It is said that the German schoolmaster won the war of 1866. The professor of 1914 lost the World War.") In December 1918 he began publication of a weekly newspaper, *Auf gut Deutsch* (In Plain German). The paper claimed a circulation of 25,000, was a scurrilous sheet, and involved Eckart in continual litigation with politicians and others who sued for slander and libel. He became a member of various anti-Semitic and ultranationalist organizations, including the Thule Society, which adopted as its official symbol the swastika and as its motto, "Remember that you are a German. Keep your blood pure." In the late summer of 1919 Eckart gave his first public lecture before what was to become the Nazi party and was soon a member of the party's inner circle. In December 1920, when the party acquired the newspaper *Völkischer Beobachter* (Racial Observer) as an official publication, Eckart handled the negotiations and made the initial payment (apparently donated by German army officers and other interested benefactors) to the previous owners. In August 1921 Eckart discontinued *Auf gut Deutsch* and became editor of the *Beobachter*.

Eckart would have to be described as a bloody-minded intellectual, knowledgeable but gross, gregarious and crude, a bon vivant without finesse—basically a dumpling-and-goose-grease man, who incorporated his anti-Semitism, his animosities, and his misogyny into his historical interpretations. (Eckart is described by Alfred Rosenberg as having a particular antipathy toward women. Thus he

"Germany under the Jewish Yoke," a cartoon appearing in Eckart's *Auf gut Deutsch* (In Plain German) in 1919. Reprinted from Margareta Plewnia, *Auf dem Weg zu Hitler. Der "völkische" Publizist Dietrich Eckart* (Bremen: Carl Ed. Schünemann, 1970).

may have illustrated a significant characteristic of the modern racist, which might be stated as "scratch a racist, and you will find a woman-hater.") He had a wide circle of acquaintances, including the Wagner family, General Ludendorff, and members of the influential National Club of Berlin—industrialists, bankers, landowners, high-ranking military officers, and university professors. He was at home in Munich's beerhalls (the Gasthaus, the Hofbräuhaus, Zirkus Krone, the Bürgerbräu-Keller, the Löwenbräu-Keller) where his rough jokes about the Jewish nose and the machinations of "Lloyd George and Co." floated through the smoke and smell in company with his harangues about the modern Antichrist, monopoly capitalism, and the true nature of the German soul. He was continually busy—writing political broadsides and then driving about Munich in an open automobile distributing the publications; lecturing at meetings on such subjects as "Against the International Jewish Stock Exchange," "The False Evangelism of Liberty, Equality, Fraternity," and "Jews and Marxists as the Gravediggers of the German Nation and the German Reich"; organizing Nazi party days; and composing marching songs (his best known was *The Storm Song*, the earliest National Socialist musical composition, where each verse ended with the words "Germany Awake!"). He introduced Hitler to the pleasures of Berchtesgaden and its retreat Obersalzberg and accompanied Hitler to the first stage drama Hitler attended after World War I—the play performed was Eckart's translation of *Peer Gynt*. In 1920, at the time of the Kapp putsch, he flew with Hitler to Berlin (it was Hitler's first experience with flying) in order that a report upon the putsch might be made to the Munich military authorities. In July 1921 Eckart played an important part in the maneuvering that resulted in the elimination of Anton Drexler as a major figure in the Nazi party and the conferral upon Hitler of dictatorial powers as unchallenged leader of the organization.

By 1923 alcohol, and possibly morphine as well, had begun to exact its price from Dietrich Eckart. In April he published his often-cited poem in observance of Hitler's birthday. But he gradually drifted into the fog of illness and sloth. When the *Beobachter* became a daily newspaper, he was replaced as editor by Alfred Rosenberg because, according to Rosenberg, Hitler decided that the person doing the work should have the title. Almost two decades later, Hitler explained that he could not have entrusted the editorship of a daily newspaper to Eckart:

From the financial point of view, there'd have been a terrifying mess. One day the newspaper would have come out, the next day not. If there'd been a pig to share, Eckart would have promised it left and right, and distributed at least twenty-four hams. Some men are made like that, but without them it's impossible to get anything started.[11]

Eckart's last contribution to the *Beobachter* was on October 18, and his final speech was at a party rally on October 30, where he joined Hitler, Julius Streicher, and others in attacks upon the Bavarian authorities. His part in the November putsch was insignificant—it is reported that he was standing on the street curb as Hitler, Ludendorff, and company marched by and belatedly fell into step. He was arrested, but soon released, and died on December 29 at Berchtesgaden.

Approximately two months after Eckart's death, on March 1, 1924, his *Der Bolschewismus von Moses bis Lenin: Zwiegespräch zwischen Adolf Hitler und mir* (Bolshevism from Moses to Lenin: dialogue between Adolf Hitler and me) was published. This fifty-eight-page pamphlet—a second edition of which appeared in 1925 under the title *Der Bolschewismus von seinen Anfängen bis Lenin* (Bolshevism from its beginnings to Lenin)—claimed to be a report of discussions that took place during 1922 and 1923, although it is certain that the text is not stenographically exact. On the red cover is the title and a six-pointed Star of David enclosing a Soviet hammer and sickle. The entire publication is a rambling, disconnected, turgid flow of words. There are one hundred and forty-eight footnotes, many horror stories from the Old Testament, and a jungle of quotations from, among others, Cicero, Schopenhauer, Martin Luther, Voltaire, Kant, Spinoza, Erasmus, and Loyola. The participants in the conversation are identified as "he" and "I" or jointly described as "poets and fighters," and there are pauses when Hitler is lost in thought—pauses suddenly broken as he rouses himself to strike the table with his hand and to make another point.

Bolshevism from Moses to Lenin is a sorry example of an anti-Semitic catechism. Hitler, for his part, stresses the mysterious threat of the Talmud, points out that Catholicism has been perverted by Jewish influence ("We are both Catholics, but may we not say this?"), and argues that even Sherlock Holmes would find it impossible to discover the extent of Jewish criminality. Eckart always agrees and adds that the murder of 75,000 Persians as reported

in the book of Esther was, without doubt, an indication of Jewish Bolshevik tendencies; that the voyages of Columbus to America were made possible by the Jews; and that he once saw the British King Edward VII: "the classic image of a stock-broker Jew." The two men exchange information regarding the "real" Jewish names of various evildoers, with Hitler explaining that while it is common knowledge that Lenin's previous surname was Ulyanov, "his true name is not known." There is no political, economic, or intellectual aberration that cannot be traced to the Jews. Since the eighteenth century they have been responsible for a long series of European disasters. They are supporters of Western liberalism, that corrosive and misleading political doctrine, which Hitler, accompanying himself by pounding his fists upon the table, denounces as the dangerous stupidities of "The Humanist! The man of tolerance, of 'Liberty, Equality, Fraternity'! The Pied Piper of Hamelin!" And the Jews are also the advocates of Marxism, with its false and inflammatory slogan, "Workers of the world unite," which, Hitler assures Eckart, "the masses believe and thus go against their own flesh and blood, against their *Volk*, and thereby bring misery upon themselves." The conversation drifts off after Hitler has announced that "Israel is the secret of world history," and that one "can only understand the Jew when one knows what his goal is." This goal is not world domination, but "destruction of the world."

All this is intellectually quite hopeless, a gruesome travesty of educated discourse, wherein two men sit about a table and lose themselves in a discussion of the All-All, the ultimate answer, the grand design that explains the triumphs and defeats of mankind. In the cruder aspects of Jew-baiting, the pamphlet does not advance beyond Hitler's earlier declarations or Eckart's previous diatribes. The conversation proposes what has been described as a "history of supreme simplification," a crass, conspiratorial interpretation that justifies itself by random pickings from the garbage pile of the past and by suggestion and innuendo moves swiftly and without hesitation to breathtakingly simpleminded conclusions. [12]

But behind the tiring anti-Semitism of this and other publications lay Eckart's interpretation of modern history and, in particular, his analysis of cultural decline. Since the late nineteenth century a large number of German intellectuals had been haunted by the question of decline and by the fear that the European historical adventure was coming to an end. Many reasons had been advanced

to explain this direction of modern history. Some saw the fault in the loss of religious faith, some in the fading of the *Bürger* ethos, with its sobriety, its confidence, and its firm grasp of everyday reality, some in the stultifying bureaucracy brought about by the highly organized nation-state and industrialization, some in the general malaise that resulted from intellectual and spiritual estrangement, some in racial pollution. But there was rough general agreement that modern history was, as Eckart expressed it, transforming the German "nest" into an "anthill," and that the basic premise of German society—that men of the same blood should long for each other—had been violated. The son had been set against the father, the wife against the husband, the citizen against the nation, the soldier against the officer, the employee against the employer, and the city against the countryside. The German lifeline was thus being fractured, and the historical aspirations of the German people were being frustrated. Hardly an important German philosopher, historian, novelist, or poet failed to comment upon this dilemma or to search for some way whereby the direction of contemporary German history might be reversed. German historical consciousness became increasingly a consciousness of crisis, an expression of the conflict between the desire for historical certainty and the brooding conviction that history was going astray. Robert Gutman, in his *Richard Wagner: The Man, His Mind, and His Music*, remarks in striking terms upon this sense of impending disaster when he writes that Wagner (and what he says could apply to others as well) in his last years:

> was alarmed to observe natural selection working against its distinctive Aryanism. At its expense, others were growing more adroit, and the gods' very own appeared headed toward erasure. Something was terribly wrong; the evolutionary machinery was malfunctioning, confusing the fit with the unfit. Instead of working toward endless improvement and Aryan perfection, it was producing racial corruption.[13]

New elements had been introduced into this discussion of historical decline by the events attendant upon World War I and the years immediately following. Did the defeat of Germany mean that the idealized German will could be thwarted, that German culture had failed the test of history and was thus ultimately to be lost as Germany became increasingly subjected to alien influences? The

fears expressed by such a question were summed up in the word *Kulturbolschewismus* (cultural Bolshevism), which came into common usage after 1918. The word, of course, was closely related to the success of the communists in Russia and expressed the alarm and animosity aroused by this new threat to the values and institutions of Europe. The Bolshevik philosophy of history appeared to be the antithesis of the definitions that had been commonly thought appropriate to Europeans, and particularly to Germans. Atheism, the materialistic interpretation—with its denial of spirit, will, and soul as historical realities—and the stimulation of class warfare throughout Europe characterized the dangers posed from the east. In 1920, the writer Hermann Hesse, in an essay entitled "The Brothers Karamazov or the Decline of Europe," argued that a new attitude, what he called "the spirit of the Karamazovs," was sweeping over the continent. This attitude was a departure from previous concepts of ethics and morality, ideas of good and evil, interpretations of the beautiful and the ugly, and proposed an entirely new approach to the understanding of European history. Hesse's analysis was a heightened literary response (and he was ambivalent in his judgments), but it did indicate an awareness that what had happened in Russia was much more than a change in political arrangements.

For those of a racial persuasion, the fact that the Bolshevik triumph had taken place in Russia was of primary importance. Since the middle of the nineteenth century, European racists had been troubled by what they regarded as the chaotic nature of Russian society, by the inability of the Russians to create viable historical forms and interpretations of historical experience. As early as the eighteen-fifties Joseph de Gobineau in his widely read *Essay on the Inequality of the Human Races* had written that:

> tenaciously wedded to the soil from which nothing can uproot them, the Slavs played in eastern Europe the same role as had been fulfilled in Asia by the Semitic masses. They formed, like the latter, a stagnant marsh in which, after brief triumphs, all the ethnically superior were swallowed.

For many Germans, Russian history was seen as a struggle between the Germanized upper classes, which provided whatever intellectual and societal structure Russia possessed, and the Jews for control of the inert, uncivilized natives. In 1879 Wilhelm Marr, in his *The Victory of Judaism over Germanism*, predicted that the Jews would

"precipitate a revolution in Russia the like of which the world perhaps has never seen," and Houston Stewart Chamberlain had warned of Russian "racial chaos," a circumstance that made it impossible for the Russians to develop a clear and definite vision of themselves. Influential Germans such as Theodor Schiemann, a professor at the University of Berlin, a widely read commentator upon Russian affairs, the author of the best-known history of Russia published in German, and an adviser to the German foreign office, argued that the Russians were basically a primitive and backward people, nomadic, incapable of education, and prone to outbursts of savage and thoughtless destruction. Any Westernization was superficial, and European influences were continually collapsing because of subversive elements, particularly the Jews. In 1916 Schiemann warned: "Russia is a danger that will remain and with which future generations will have to deal, unless we release them from this danger."

The victory of the Bolsheviks, in company with the defeat of Germany in 1918, transformed this fear of Russia from a historical speculation to a clear and present danger. Germany, at her weakest moment, was exposed to the full force of alien pressures. German salients to the east had been outflanked, and there appeared to be few defenses against the pernicious doctrine and influence of the revolutionaries in Moscow. Into Germany streamed a collection of violent reactionaries, exiled cranks, and self-declared authorities upon the evils of Bolshevism, who had been driven from Russia and brought with them the argument that events in the Soviet Union were evidence of a worldwide plot aimed at the destruction of all religions, all family arrangements, all national groupings. A vicious form of underground literature spread from Germany throughout the Western world. Now-obscure men such as F. V. Vinberg, Peter Shabelsky-Bork, Sergei Taboritsky, K. V. Sakharov, and N. E. Markov published warnings under such titles as *The Wars of the Dark Powers, The Hidden Hand,* and *Bolshevization of the World.* Here it was pointed out, with gruesome details and alarming predictions, that there existed a Jewish-Bolshevik plot (at times, a Jewish-Mongol plot) to subvert Western politics, destroy Christianity, and subjugate the Aryan race.

Included among the exiles were members of the Baltic German nobility and the Baltic German middle class who settled in Munich and became involved in the activities of the young and

struggling Nazi party. Men such as Max Erwin von Scheubner-Richter and Alfred Rosenberg, who through his wife—a professional dancer—met Dietrich Eckart and then, by the good offices of Eckart, Adolf Hitler, were convinced that the Bolshevik revolution constituted an attempt by the Asiatic-Jewish underworld to undermine and then destroy European civilization. Germany, cleansed of corruption and confusion, was the only defense against this threat, and in what at the time could only have been a most inflated view of the importance of the Nazi party, Scheubner-Richter and Rosenberg contended that the fate of Europe would be decided by the struggle between Nazi and Bolshevik.

Cultural Bolshevism did become a cliche and was used to describe anything offensive to personal taste, particularly in the area of aesthetics. It was applied to the impulse prompting anyone to paint a horse blue, and when Siegfried Wagner saw a "cubist" production of *The Flying Dutchman*, he could think of no response save to dismiss the experiment as an example of cultural Bolshevism. But for Dietrich Eckart the phrase (or, in German, the word) carried a heavy burden of historical speculation and appeared to identify those foreign and subversive dangers to German racial integrity, those denials of a German heroic interpretation of life. Cultural Bolshevism was alien, being principally the creation of the Jews and now encouraged by the Russian communists, and disputed the claim, so important to Eckart, that the future of Europe belonged to the Germans. It rejected the possibilities of any tragic interpretation of history and declared that the German will, the German soul, the German urge to the light were fictions. Cultural Bolshevism argued that modern history transcended racial definitions and proposed a destructive class interpretation, declaring that the significant human allegiances were to vulgar economic groupings, a grubby dedication to the belly rather than to the heart.[14]

How was such a perversity to be combatted? Here Eckart had some ideas that were to be implemented when Hitler came to political power. Eckart argued that the way of salvation for Germany (and Germany was, for him, what remained of the true Europe) was to abandon the concept of *Kulturträgertum*, the spreading of German culture among those regarded as backward peoples. The European venture into the world during the eighteenth and nineteenth centuries, a venture in which Germany had participated, had been a disaster, as had been the European invitation to peoples

of diverse racial characteristics and different historical experiences to participate in European culture. The calamitous results of the attempt to incorporate the Jews into German life, the cruel fate of the Germans in Russia following the Bolshevik revolution, and the circumstances of World War I, when Germany found itself largely alone against a hostile world alliance, indicated that all efforts to make the benefits of German culture available to non-Germans were certain to fail. Germany must, therefore, be brought back to the essentials, to the bare-bone virtues of the tribal unit, and there must be a hoarding of the precious treasure of German blood and German spirit. In the twentieth century Germany must exist as a barricaded island of gold in a sea of filth. What Eckart thought of as cosmopolitan confusion must be replaced by parochial security. His concept of the Reich meant a rejection of the complexity of modern European history and announced the necessity of a single, narrow focus of German experience.

Eckart, like Hitler, had a stunning indifference to the world outside of Germany. He had no empathy with the varying experiences of humanity and lacked any of that emotional and intellectual urge to learn of strange places and strange gods that had been so much a part of the restless European spirit. He was a true landlocked continental, a stay-at-home mythomaniac, engaged in his own backyard in what he regarded as a cosmic struggle. His energies were consumed by his almost-erotic love of things German: the German striving for the light, German idealism, German heroism, the German expression in a decadent world of the classic virtues of a direct response to life.

In Eckart's historical interpretation, art—painting, sculpture, music, and literature—played a crucial part. German art was rooted in German racial distinctiveness, was nurtured by German racial memories, and was a "witness" to the German right to existence. There was art that was world-denying *(Weltverneinung)*, and there was art that was world-affirming *(Weltbejahung)*, and it was the latter that presented the truth about Germany, spoke to the German racial and cultural experience, and avoided those transitory phenomena that only confuse and frustrate. Inferior and depraved artists concerned themselves with reality *(Wirklichkeit)*, the day-to-day expression of life's routine. But the significant artist projected truth *(Wahrheit)*, the basic heroic trait of the German people and the most forceful influence in German history. True German art provided

direction for the driving German will, ended modern loneliness, chaos, and confusion, and protected the threatened racial insights of heroism and courage. The artist must be a seer, not a mere entertainer and, therefore, must present a definite, clearly recognizable conception of the German self that would promote certainty in confronting the dangers of modern history. German art must be a faithful representation of German racial life, but transfigured by what Eckart thought of as classical idealism. It would then be "German and true," an expression of the racial tie that binds, of the essential condition for the existence of the German community. Art that attempted to express such things as the conscience of the world, the brotherhood of men, class identification, pacifism, or cosmopolitanism could only promote a weakening of the German sense of identity and destroy the German will. And any art unrelated to the racial, idealistic demands of German history—expressionism, abstraction, Dadaism—was a dangerous absurdity, a perversion practiced by charlatans and dilettantes.

Eckart stressed the communal response to art and claimed for art a ceremonial function that bound the painter, the sculptor, the musician, and the poet tightly to the community. Only such a clear and abiding connection could protect artists from becoming a weary collection of solitary wanderers, homeless, unfruitful, and decadent. Art was a celebration of German racial and historical aspirations, and it was through art that the Germans could make that leap from the confusion of everyday life to the security of high culture. Artistic creativity was thus not expressed through the wayward efforts of the isolated, introspective individual but, rather, through the activities of those who responded to the inarticulated demands of the collective folk memory, to the German longing for the heroic and the eternal. In reality, Eckart, the apostate Catholic, assigned to artists many of the functions of the priest, and made them the tenders of the sacred flame of racial and national integrity. And he advocated a form of cultural *Gleichschaltung*, a coordinated unity, whereby only those attuned to the historical necessities of the German people and willing to accept the burdens of laboring on behalf of the people could claim the position of artist.

In his aesthetic judgments, as in his historical interpretations, Eckart was influenced by his fear and hatred of the Jews and his disdain of the Slavs. Both of these groups he dismissed as incapable of true cultural activities. But he was also determined to establish the

supremacy of German art over French. It is doubtful if Eckart possessed any meaningful knowledge of French art, and his comments upon the subject are almost exclusively extrapolations of the insulting and inflammatory attacks upon France and the French that had been so much a part of the writing of a certain type of German critic since the last half of the nineteenth century. Putting down the French had been a popular undertaking by German nationalists, who had forwarded the idea that the health of German culture must, of necessity, indicate the diseased nature of France. (In *Die Meistersinger* Hans Sachs delivers a brief anti-French sermon in which he points out that French influences will destroy serious German art, while Paris was frequently described by Wagner and others as the "abyss of utter vulgarity" and as the *"femme entretenue* of the world.") In Eckart's view the French were corrupt, cynical, nervous, and erratic, characteristics traceable to their racial confusion and the influence of the Jews upon French life. Moreover, the French thought like women, not like men, lacked idealism, and were unable to rise above their narrow, cramped, bourgeois view of the world. They possessed a shopkeeper's mentality and at best were a superficially attractive but essentially frivolous people. As would be expected, their art could only express the trivial, the lewd, the bizarre, and the contorted, and the French artist was attracted to the lascivious and the mundane. Absinthe drinkers, blowsy nudes, dull-witted peasants, grotesque clowns, hypocritical patriots, distorted landscapes—these were the subjects of French art, and the French painter was unable to transcend his material and project any European ideal. Therefore, German art stood alone as a manifestation of healthy European culture, and every effort must be made to protect this heritage of blood and spirit from the deleterious influences that threatened it.

Throughout his adult life Eckart had been an opponent of any form of parliamentary government. And, after 1918, he had no faith in a restored German monarchy. Neither of these could express heroic vitalism and rise above political maneuvering. Only a new type of leader could reverse the downward spiral of German history and become an effective manifestation of the German will. Thus Eckart became an early exponent of the *Führer* mystique of the Nazi movement, and he argued that out of the wreckage of the times would come a new kind of intellectual-artist, a soldier, ruthless, with undisputed authority, and possessing those cultural insights neces-

sary to rescue Germany from her enemies and even from herself. The leader would demand and receive absolute allegiance and would provide a definite world view that would never compromise itself by mere political tactics. When acting to forward the racial destiny of the Germans, he would not allow himself to be restrained by any arguments about legality, and he would understand that violence, when used for ideological purposes, is an appropriate historical instrument. Such a leader would realize that the struggle to save Germany and Europe is not simply a political, economic, or military problem but involves a conflict of ideologies, and the result of his efforts must be the restoration of cultural order to the continent.

Eckart had originally considered Wolfgang Kapp, who had been involved in an unsuccessful attempt to overthrow the German government in the spring of 1920, as a possibility for the position of leader. However, he soon discovered that Kapp was "too primitive," too much the Prussian bureaucrat, too lacking in true ideological motivation. Kapp was also a "cultural cipher." But an authentic candidate was present in Munich, and from the summer of 1920 until his death, Eckart gave his full allegiance to Adolf Hitler. Here was one who understood what was happening in Germany and Europe, who possessed ideological fanaticism, and who was capable of rising above politics to that high level of cultural dedication so necessary if the disgrace of contemporary Germany was to be avenged. Hitler's anti-Semitism was beyond suspicion; he understood the true nature of the Bolshevik threat; he possessed dogmatic tenacity; and he had an artistic temperament.

Eckart gave Hitler the trench coat that became so familiar in the nineteen-twenties, and some have suggested that Hitler's moustache was modeled after Eckart's. But more important influences can be identified. If, as it is argued, Hitler's ideology carried the smell of the tavern, then at least some of that odor can be traced to Eckart, the beer-hall philosopher. Eckart was not, as was dull, pedantic Alfred Rosenberg, a caricature of a scholar, nor was he, as were so many of the other Munich Nazis, simply an empty-headed thug. He had the rather remarkable talent for giving vulgarity the appearance of historical profundity and for presenting animosity and frustration as the manifestations of historical purpose. Or, as Hitler put it: "Dietrich was a writer full of idealism." Undoubtedly, he fortified Hitler's confidence in his political and aesthetic judgments, and he projected the image of the man of culture as a committed political

activist. Eckart provided a thin intellectual veneer to the belief that desperate times called for desperate actions, and, perhaps alone among the early Nazis, he expressed his anti-Semitism, his hatred of liberalism, his fears of cultural decline, and his discomfort with modernity in a form that made a direct and lasting appeal to Adolf Hitler.

Dietrich Eckart died at the low point of Hitler's political fortunes, when the party was scattered and Hitler himself under arrest following the failure of the November putsch. On November 21, 1923, a month before his death, Eckart summed up his hatreds, his despair, and his loyalty to Hitler in the following coarse, brutal poem.

> Stupid race! You slandered all
> Who strove on your behalf.
> With blasphemous talk
> You repaid even Hitler's kindness,
> Grunted, as the Pharisees
> Secretly drove him down.
> But now the Hebrew comes,
> On foot your master comes!
> Your ears will feel his whip,
> And your snouts, too, lest you forget—
> Born to the slave's yoke,
> You still think only on your fodder!
> Thank God, what Hitler had in mind
> Is now denied him,
> And he's spared the shame
> Of having freed you animals![15]

4

THE
CONFRONTATION

"Events in Germany have deeply shocked me, and yet I am proud that those brown-shirted iconoclasts are also attacking and destroying my pictures. I would feel insulted if that kind tolerated me."

Ernst Kirchner[1]

On January 30, 1933, Adolf Hitler became chancellor of Germany. In numerous photographs and newsreels we see him as he stands in triumph and receives the noisy approval of the uniformed Nazis marching in parade through the streets of Berlin. Behind him were the countless party meetings, the political rallies, the intrigues, the speaking, speaking, speaking. Before him were the actions that would be associated indelibly with his career as a historical personality: the near-destruction of European Jewry, the physical desolation of a continent, and the end of Germany as a major national power in the world.

Hitler had spoken frequently in earlier years of accounts he had to settle with a large number of enemies, and he had included modern artists among those who would feel the force of his anger. In

71

1930 he had, in a letter, assured Josef Goebbels that when they came to power the National Socialists would not become a debating society concerning the place of art in the community but would carry out the provisions of the party platform of 1920 that called for a struggle against the "tendencies in the arts and literature which exercise a disintegrating influence on the life of the people."[2] And soon after the Nazi political victory, the first measures were taken that would determine what Hitler called "the artistic line of march." The most important of these occurred on March 11, 1933, when the Reich Ministry for Popular Enlightenment and Propaganda, ultimately to become the institutionalized authoritative source for Nazi cultural activities, was established, with Goebbels as Reich Minister.[3]

Some specific actions against individual artists and their supporters were taken almost immediately. George Grosz, who was on a visit to the United States, was stripped of his German citizenship; the Bauhaus was closed; Käthe Kollwitz and Max Liebermann were expelled from the Prussian Academy of Arts; and Paul Klee, Max Beckmann, Otto Dix, and Oskar Schlemmer were dismissed from their teaching positions, dismissals that were given retroactive legal sanction by the Law for the Reestablishment of Professional Officialdom of April 7, 1933. Heinrich Ehmsen, who had been one of the more radical painters in the years following World War I and whose best-known work was the triptych *The Shooting of the Sailor Egelhofer*—an artistic interpretation of an actual event in 1919 when the twenty-six-year-old sailor Rudolf Egelhofer had been commander-in-chief of the Red Army at the time of the Munich Soviet regime—was arrested. Two months after Hitler's assumption of office, demands were made that Ernst Barlach's Magdeburg memorial be removed from the cathedral, and the work was subsequently crated and shipped to Berlin for storage. This and other early attacks upon Barlach were undoubtedly related to the fact that on January 23, one week before Hitler came to power, Barlach, in his first and last public political statement, had delivered a radio address, wherein he spoke of Hitler as "the lurking destroyer of others" and described Nazism as "the secret death of mankind."[4] Many of the significant art journals devoted to the modernist movement were quick victims of the new regime. Herwarth Walden departed Germany for the Soviet Union, where he was to die in 1941, and his publication *Der Sturm*, which had played such an important role in

publicizing the new German art in the years prior to World War I, ended with the last issue for 1932. The periodical *Die Aktion*, initiated in 1911, also died with the Weimar Republic. *Kunst und Künstler*, which had published a large number of original prints, including Barlach's *A Journey to the Steppes* and Beckmann's *From the House of the Dead*, was suppressed by the Nazis, as were *Kunstblatt* and *Museum der Gegenwart*, the publication of the German Museum for Contemporary Art. In 1919 Karl Schmidt-Rottluff had been commissioned to redesign the German imperial eagle as a symbol appropriate to the new republic, and casts of the more docile and less predatory bird had been placed on buildings throughout Germany. In 1933 the Nazis removed the Weimar eagles from public view.

But, as was true of other aspects of the Nazi program, there was initially some confusion as to how the party philosophy in the area of art should be implemented, and there were competing arguments put forward by various claimants to the position of cultural spokesman. For approximately a year and a half after the Nazi political victory, controversies swirled about the question of what should be official policy. Alfred Rosenberg, who became director of the Office for the Supervision of the Cultural and Ideological Education and Training of the Nazi Party on January 1, 1934, thought of himself as a leader and theoretician in the area of Nazi aesthetics and advocated a hodgepodge of ethnic and national attitudes that concentrated upon what he thought of as ancient German virtues. Rosenberg had gathered about him a large number of those happy to engage in organizing boycotts of teachers at art academies, in purging museums, and in vilifying modern artists. Apprehensive about the growing power of Goebbels in the area of the arts, Rosenberg attempted to bring the party policy into line with his own philosophy and engaged in a series of bickering disputations with Goebbels and others over the control of the arts in the new Germany.

A particular source of concern for Rosenberg and his supporters, including Reich Minister of the Interior Wilhelm Frick and the architect and critic Paul Schultze-Naumburg, was the belief on the part of some that they could serve both Adolf Hitler and modern art. Painters and art critics who were unimpressed by the folkish attitude, and by Rosenberg himself, argued that the works of Barlach, Kirchner, Heckel, and others were truly German and had even been prophetic indicators of the coming to power of the Nazis. The poet Gottfried Benn sympathized with this approach, and in

November 1933 he published an article wherein he called German expressionism the "last great resurgence of art in Europe" and declared that the antiliberal and irrational aspects of such art qualified modern painters and sculptors to contribute to the Nazi cultural program.[5] Young artists who were members of the National Socialist Students Association in Berlin attempted to illustrate the union of Nazism and modern art by sponsoring an exhibition in the summer of 1933 that included works by Pechstein, Schmidt-Rottluff, Nolde, and Barlach. After three days, however, the exhibition was closed by Minister of the Interior Frick, and the leaders of the venture were ordered expelled from the Students Association. At the same time the Director of the National Gallery in Berlin prepared a showing of modern art that would indicate the German quality of Barlach, Nolde, Feininger, Marc, Kirchner, and others. The exhibition was prohibited, and the director was relieved of his responsibilities.

Strains within the party continued, stimulated by the animosity of Goebbels and Rosenberg. Goebbels's organizational talents far exceeded those of Rosenberg, and while Rosenberg wrote letters, made speeches, and engaged in a flurry of cultural activities, Goebbels consolidated his position. By the end of 1933 an official Chamber for Arts and Culture had been created under Goebbels's control, with separate sections designated for film, theater, music, literature, and art. All artists were required to join a government-sponsored professional organization; only members of such an organization were allowed to exhibit in museums or to receive commissions; and no public art showing was to be held without official approval.

Then, at the party's annual meeting in September 1934, Hitler set forth the straight way that would be followed, resolved the controversies, and established himself as the authoritative voice in cultural matters. In a speech to party leaders, he spoke of two cultural dangers that threatened National Socialism. First, there were the modernists, the "spoilers of art"—those he described as "the cubists, futurists, and Dadaists." There was no place in Germany for modern art, and Hitler declared that such "charlatans are mistaken if they think the creators of the Third Reich are foolish or cowardly enough to let themselves be befuddled or intimidated by their chatter." Henceforth, he stated, German art would be "clear," without contortion and without ambiguity. He would not tolerate any "cultural auxiliary to political destruction," and he demanded that art become a functioning part of the Nazi political program.

Having disposed of modern art, Hitler then laid the ax to the program enunciated by Rosenberg and his followers. He denounced "those backward-lookers who imagine that they can impose upon the National Socialist revolution, as a binding heritage for the future, a 'Teutonic art' sprung from the fuzzy world of their own romantic conceptions." Hitler ridiculed those who would "offer us railroad stations in original German Renaissance style, street signs and typewriter keyboards with genuine Gothic letters, song tests freely imitated from Walther von der Vogelweide, fashions borrowed from Gretchen and Faust, pictures of the 'Trompeter von Säckingen' type." And he ordered those engaged in such foolishness to cease their activities; they were no longer to "spook about molesting people and giving them the shudders."[6]

The official policy had now been defined, and subsequent events were to show that there was to be no significant deviation from the direction pointed by Hitler. Goebbels, who had earlier shown a favorable response to the work of Nolde and Barlach, adjusted himself to Hitler's directive, while Rosenberg, having suffered another in a long series of humiliations at the hands of Hitler, drifted into the fog of ineffectualness in the Nazi party. Judgment had been made upon modern art. Additional confiscations now took place, more artists were expelled from teaching and museum positions, and steady pressures drove painters and sculptors from public life. In early 1935 the magazine *Kunst der Nation*, which had been initiated in October 1933 and had attempted to support modern art without offending the Nazi leadership, was suppressed, while by this date showings of the works of modernists were occasional and largely private affairs by a handful of dedicated and courageous gallery owners. It became difficult even to print reproductions of modern art. In 1934 the published collection of Klee's drawings had been confiscated almost as the books came off the press, while in 1936 the entire edition of a catalog of the works of Franz Marc was seized by Nazi authorities (an art historian who coincidentally attempted to deliver a speech in observance of the twentieth anniversary of Marc's death was arrested), and four thousand copies of a volume of Ernst Barlach's drawings—described as a danger to "public safety, peace, and order"—were destroyed by the Gestapo.

In October 1936 the modern section of the National Gallery in Berlin was closed, and a month later all unofficial art criticism was forbidden. Only factual reporting of art events was permitted, and any journal concerned with art was required to secure special au-

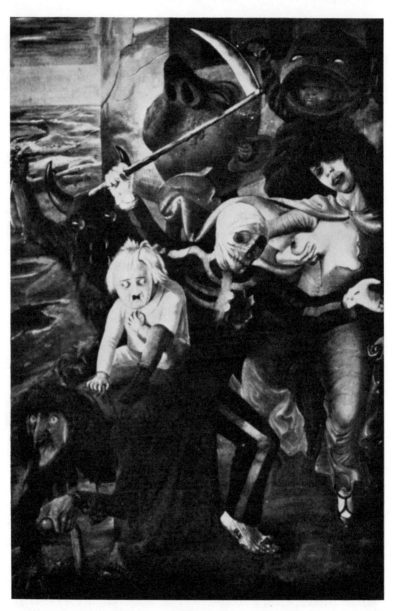

Otto Dix's 1933 *The Seven Deadly Sins*. Hitler, easily recognizable by the moustache and the eyes, is portrayed as Envy. Staatliche Kunsthalle Karlsruhe.

thorization from the Reich Minister for Popular Enlightenment and Propaganda prior to publication. The decree issued by Goebbels was direct and unqualified:

> I forbid once and for all the continuance of art criticism in its past form, effective as of today. From now on, the reporting of art will take the place of an art criticism which has set itself up as a judge of art. . . . The reporting of art should not be concerned with values but should confine itself to description.[7]

Hitler's personal attitude toward criticism—aesthetic as well as political—had been clearly stated in comments to representatives of the foreign press on April 6, 1933:

> The right to criticize must be recognized as an obligation to truth, and truth can only be found within the framework of the task of maintaining a people's life. Never must criticism be an end in itself. He who frees criticism from the moral duty of placing itself in the service of a general, recognized, and pursued life-task is treading the path which leads to nihilism and anarchy.[8]

In a speech in Hamburg on August 17, 1934, he had expressed himself more succinctly: "In my eyes criticism in itself is not an important function in life. The world can live without critics. . . ."[9] And approximately a year before his death, on March 13, 1944, he spoke on the subject, perhaps for the last time: "If we were to be deprived of art critics, we should not lose very much."[10]

There were, of course, protests by individual artists against the treatment accorded them. Kirchner, upon being ordered to resign from the Prussian Academy, complained that "For thirty years I have struggled for a new, strong, and true German art and will continue to do so for as long as I live." He also gave assurances that he was "neither a Jew nor a Social Democrat."[11] Max Pechstein explained that one of his sons was a member of the SA, that another had been enrolled in the Hitler Youth, and that he himself had fought on the western front during World War I. Nolde, a declared supporter of the Nazis who in his 1934 autobiography, *Years of Struggle*, had attacked the paintings of "half-breeds, bastards, and mulattoes," argued in a letter to Goebbels that his art was vigorous, durable, ardent, and German.[12] When a Nazi official in Mecklenburg described Barlach as a *Volksfremd* (one alien to the German people) and invited him to emigrate, the sculptor replied:

The sitting room in Hitler's Munich residence. Adolf Ziegler's *The Four Elements* hangs above the fireplace. Becker Collection.

I have lived in Mecklenburg for thirty years . . . there is scarcely a person in all Germany who has, from the very beginning, derived more of the form and essence of his work from his close ties with the German nation. . . . I am so deeply rooted in this country that the thought of leaving, of seeking my fortune as an emigrant, is very far from my mind. I shall stay at my post whatever the consequences.[13]

Carl Hofer published a letter in a newspaper in which he contended that the Jews had exercised little influence upon modern German art. And Schlemmer, in April 1933, wrote to Goebbels to complain about the removal of his paintings from the public gallery in Düsseldorf. He also asked Goebbels to intervene in the movement to expose modern art to "the mockery and indignation of the public," and protested against the manner in which modern painters "have been branded as alien, un-German, unworthy, and unnatural. The political motives ascribed to them are in most cases totally inappropriate."[14] Five months later, in October, Schlemmer wrote to Gottfried Benn in response to Benn's recently published *The New State and the Intellectuals* (an impassioned defense of the Nazis) to point out that, contrary to the poet's belief, the condemned "decadent" artists were not being replaced by creative and imaginative individuals but by "tried and true purveyors of kitsch."[15]

None of these actions aroused sympathetic response, and the harried artists could only counter the force of massed Nazi authority with basically ineffectual ripostes. Dix, in 1933, included a caricature of Hitler as Envy in his *The Seven Deadly Sins*, and Oskar Kokoschka, then living in Prague, in 1937 attempted to satirize the Nazis by painting his *Self-Portrait as a Degenerate Artist*. Beckmann—to close friends—mocked Hitler as a "Verführer," a misleader or seducer, and it has been suggested that when in 1936–37 he painted the triptych *The Temptation of Saint Anthony*, he inserted the goose-stepping, grim-faced bellhop as a portrayal of Hitler, with the bellhop's legs and the arms of the female victim on the ground forming a swastika. Lyonel Feininger's *Red Fiddler* of 1934 has been described as a comment upon Hitler, who is playing a fiendishly artful melody leading to destruction, and in 1937 Barlach completed a plaster version of a sculpture of a young, gaunt, suffering woman entitled *The Evil Year*. Klee did a series of drawings (the majority unfortunately lost) to express his hatred of the Nazis, and Hofer, in 1943, predicted the future of Hitler's Germany with his *Man in the Ruins*,

where a naked and battered figure is set against the charred and broken remains of a blasted city. Liebermann, who in August 1914 had been one of ninety-three well-known intellectuals signing a widely distributed manifesto justifying the German invasion of Belgium in World War I, remarked upon being notified of his expulsion from the Prussian Academy: "I couldn't possibly eat as much as I would like to puke."[16] Schlemmer wrote to the director of the art museum in Essen to point out that he would never consent of his own free will to the removal of his murals: "I feel that one can justifiably give in to this cultural barbarism only under pressure, never voluntarily."[17] Grosz, who in 1925 had ridiculed Hitler as a self-proclaimed savior in Nordic bearskin, and who resided in the United States after 1933, contributed a large cartoon of Hitler to the anti-Axis rally in New York City in 1940.

But these were pathetic responses to the condemnation of Klee's "foolish scribblings," of the "subhuman style" of Kollwitz and Barlach, of that "technical bungler" Nolde, of the "ethical nihilism" of Dix and Grosz. Kollwitz commonly answered questions by her grandchildren with the phrase, "Hitler is an ass" ("Hitler ist ein Esel"), but any overt act of opposition was dealt with harshly by the Nazi authorities. In April 1935 the novelist and poet Ernst Wiechert, in a speech at Munich University, protested against the introduction of politics into art and literature and attacked politically motivated art critics, an action undoubtedly responsible for his subsequent incarceration in Buchenwald.[18] In 1939 Dix was jailed because of an unsubstantiated accusation that he had been involved in an attempt upon Hitler's life in the Munich Bürgerbräukeller, and in 1944 Hofer was confined to a sanitarium as punishment for his general recalcitrance. In what must be seen as a vindictive gesture, the Nazis refused to provide an exit visa for Pechstein so that he could accept offers to teach in Mexico and Turkey. As Barlach commented upon the position of the artists: "A pimp or a murderer is better off. He at least gets a legal hearing and can defend himself. But we are simply repudiated and, whenever possible, purged."[19] Avoidance of trouble, not protest, became a way of life for painters and sculptors. Beckmann hid his *Departure* in the attic and, in an attempt to mislead any inquisitive official, wrote on the back of the canvas, "Scenes from Shakespeare's *Tempest*," while Nolde took works with him to the hospital during an illness in order to guard against the possibility of an unexpected police search of his home. In

the unequal contest, the artists had two debilitating options. Many left the country, Klee going to Switzerland, Feininger to the United States, Beckmann to the Netherlands, Heinrich Campendonk to Belgium and then to the Netherlands, Rudolf Belling to Turkey, and Ludwig Meidner to England. Shortly before his death in 1935, Liebermann wrote of what he saw as the only possible way open for young German-Jewish artists: "There is no other salvation than emigration to Palestine, where they can grow up as free people and escape the dangers of remaining refugees."[20] Others—Barlach, Dix, Kollwitz, Nolde, Schlemmer, Hofer, and Heckel—remained in Germany, to be attacked as degenerates and, in some cases, placed under police surveillance.

Those painters and sculptors who could not or would not depart Germany continued, under increasingly difficult circumstances, to work when and where possible. In 1935 Barlach completed *The Frieze of Listeners*, where the figures appear to be transfixed by some strange music or some mysterious word, and where the central figure, a blind man leaning on two canes, bears the features of Barlach himself. In 1936, Barlach wrote his last play, *The Count of Ratzeburg*, which was not to be published or performed until 1951. Burdened with age and sorrow, Kollwitz, whose grandson was to be killed in World War II as her son had been killed in World War I, and whose works were to be seen in isolated showings until 1937, completed in 1935 eight lithographs known as the Death Series, where, in what must be regarded as a moving comment upon her long life, she showed death talking into the ear of a woman, supporting a young girl in his arms, summoning an old woman with a light touch on the shoulder. She did *The Protecting Mother* in 1937, *Pietà* and *Tower of Mothers* in 1938, and her last self-portrait, in charcoal, in 1943. Although there was no possibility of exhibiting, Beckmann continued to work. By the end of 1933, he had painted *Departure*, his first triptych, with its severed hands, its contortions, and its symbolism of impending violence, and in 1935 completed *The Organ-Grinder*, a picture where plants spring through the floor, spears rest alongside mirrors and picture frames, and costumed figures appear as puzzled actors in some confusing drama. Because he dared not use oils for fear their odor might compromise him (he had been forbidden to engage in any artistic activity), Nolde, from 1938 to 1945, painted more than thirteen-hundred watercolors—on scraps of rice paper that varied in size from five to ten inches—which he called

"Unpainted Pictures" and carefully hid from all eyes save his own. In October 1944 he wrote that "only to you, my little pictures, do I sometimes confide my grief, my torment, my contempt."[21]

The harassment of painters and sculptors was, superficially, something in the nature of a police action, a crude use of force to intimidate and to create a climate inhospitable to any potential opposition. But as Hitler's raging anti-Semitism could not be relieved by mere vandalizing of Jewish commercial establishments or by applying legal restrictions on Jews, so, too, his attack upon modern art was prompted by much more than simple disgust at what he thought of as the outlandish use of color and a distorted perspective, by more than a determination to remove offensive pictures and statues from public view. In aesthetics, as in politics, Hitler was an activist. He would not only suppress what he thought of as evil but would stimulate painting and sculpture that could carry his racial and national message. Art must contribute to the Nazi society, must possess historical and racial authenticity, for, as he argued, every race has its artistic ideal of beauty, and through reference to this ideal, Germans recognized themselves, historically and culturally.

Hitler believed that a model for such racial and German art was at hand in what he thought of as classical painting and sculpture. As Johann Winckelmann in his 1763 *History of Ancient Art* had advocated what he called the "noble simplicity and tranquil greatness" of Greek and Roman art as a defense against any "confusion of form," any "immoderation of expression," so Hitler was convinced that the classical era had shown how image and thought could be united, how material and spirit could be made one. He was attracted to that vision of the classical world that had haunted German philosophers and historians and had established what has been called the tyranny of Greece over Germany. Despair over a hated present had forced many Germans to seek refuge in thoughts of a pristine classicism, and Fritz Ringer, in his *Decline of the German Mandarins*, has noted that a large number of scholars in the nineteen-twenties argued that reliance upon Greek and Roman models could serve as a stimulant to German national consciousness and as an antidote against materialism, utilitarian rationalism, and intellectual confusion. Similarly, Hitler saw the integrated, wholesome classical image as an alternative to an indiscriminate and problematic modernity, as an inspirational expression of the racial spirit and national harmony.

In 1938 Hitler pointed out in an address that "The art of Greece is not merely a formal reproduction of the Greek mode of life, of the landscapes and inhabitants of Greece; no, it is a proclamation of the Greek body and of the essential Greek spirit."[22] Thus, for him, classical art and classical spirit were united in a timeless vision that existed independently of the misadventures of life. Classical art, which he once defined as "functionalism fulfilled with crystal clarity," satisfied Hitler's need for order and catered to his desire for an aesthetic form that would be purged of idiosyncrasies and ambiguities. Such art was, in his view, an ordering of the chaos of life— not a surrendering to that chaos—and a source of historical certainty. It was an expression of a basic truth, and through it one made contact with a beauty that could not by other means be attained, with some haunting historical memory that could not otherwise be represented, with some heroic stance that could not be achieved in any other way. He spoke of "the beautiful clarity of the ancient world," and Percy Ernst Schramm has written that "Hitler was not only island oriented; he was completely rooted within the cultural boundaries of the old Roman Empire. He clung to the civilization of the Mediterranean world."[23] Hitler believed that the true course of European history had run from south to north, from Greece and Rome to Germany, and that certain unalterable characteristics of that history, derived from the classical peoples, were embodied in Nazi Germany. (Of the sixteen art books in his personal library, thirteen dealt with architecture and city planning; the remaining three with the connection of the classical world and German culture.) As he stated in *Mein Kampf*: "Roman history correctly conceived in extremely broad outlines is and remains the best mentor, not only for today, but probably for all time. The Hellenic ideal of culture should also remain preserved for us in its exemplary beauty."[24] And Konrad Heiden relates that Hitler pointed out to him that:

> The ideal of beauty of the ancient peoples will be eternal as long as men of the same nature, because of the same origin, inhabit the earth. . . . Every politically heroic people seeks in its art the bridge to a no less heroic past. The Greeks and Romans, then, become so close to the Germans because they must all seek their roots in one and the same basic race, and here the immortal achievements of the ancient peoples exert again and again their attractive effect upon their racially related descendants.[25]

Thus the classical Mediterranean societies had established lasting and authentic standards—not only for themselves but for the Germans as well. Hitler assured Otto Strasser in 1930 that "There is no such thing as a revolution in art: there is only one eternal art—the Greek-Nordic art—and anything which deserves the name of art can always only be Nordic-Greek. . . ."[26] Nor could there be any substitution of some ancient, so-called German art for the classical models. Heinrich Himmler and others might busy themselves searching for examples of the glories of an early Teutonic age, but Hitler scorned such activities and complained:

> Why do we call the whole world's attention to the fact that we have no past? It isn't enough that the Romans were erecting great buildings when our forefathers were still living in mud huts; now Himmler is starting to dig up these villages of mud huts and enthusing over every potsherd and stone ax he finds. All we prove by that is that we were throwing stone hatchets and crouching around open fires when Greece and Rome had already reached the highest degree of culture. We really should do our best to keep quiet about the past.[27]

Several years later, he dismissed the claims of those extolling the aesthetic prowess of the early German peoples with a single sentence: "I am afraid I cannot share their enthusiasm, for I cannot help remembering that, while our ancestors were making these vessels of stone and clay, over which our archaeologists rave, the Greeks had already built an acropolis."[28] Hitler had little interest in old German art (he described the paintings of Matthais Grünewald as ugly) and stated categorically: "When we are asked about our ancestors, we should always point to the Greeks."[29] Although he was occasionally intrigued by the idea that the Dorians might have originally migrated to Greece from Germany, any talk of Norse runes and Baltic carvings bored him. The German idea of beauty must be that of the Greeks, who had achieved perfection, and "If we consider the ancient Greeks, who were Germanics, we find in them a beauty much superior to the beauty which is widespread today—and I mean also beauty in the realm of thought as much as in the realm of forms."[30] The Greeks and Romans might be distant in time, but in culture they were "eternally near." In September 1937 Hitler stressed this point in an address: "The sculptor of classical antiquity, who endowed the human body with form of wonderful beauty, has given to the whole world beyond his description of an idea of what according to later, so-called scientific research is correct, that is to say, real."[31]

If the classical peoples had created art forms that spoke culturally and racially to the Germans, then no purpose was served by artistic innovation, and the search for new, nontraditional aesthetic experience was only a sign of decay or caprice in those who did not respond to the attraction of a heroic, idealistic art. "Minds that give birth to something new are infinitely rare," Hitler argued. "It is only a few great men on earth who really bless nations by new achievements. More than that is not necessary. . . . We need to produce no new art. If we accomplish nothing better, let us concentrate on what we already have, on what is immortal."[32] In the same tone, he spoke at the opening of the Exhibition of German Architecture, Arts, and Crafts in 1938: "There are things that do not admit of discussion, and among these are eternal values. Who could presume to apply his puny, commonplace intellect to the creations of truly great, divinely endowed natures?"[33]

This simplified view of classical art satisfied Hitler's aesthetic longing for an eternal form that would exemplify the racial immortality of the Germans. He saw the art of the ancient world as uniform, orderly, and elevating, and the externalization of the classical image left nothing in obscurity. Wayne Andersen has expressed dramatically the attraction that classical art had for someone such as Hitler and, incidentally, has provided a valuable insight into an important aspect of Hitler's idea of the hoped-for racially pure community:

> Ancient Greece in the eyes of a nineteenth-century romantic languished across time like Lady Eden, unthreatened by the Fall. The primary quality of this most romantic of pastures was its balance. Activity took the form of a ballet of stylized gestures, each incumbent being assigned his fated task, his ritualized share in life. The population was composed of graces of both sexes and varied ages—but sex and age were treated as functions rather than as states of being. A woman lived out her woman's role into eternity; an aged man disseminated wisdom for all time. Sensuality was a concomitant of the flesh and existed as a natural fact, impersonal and without voluptuousness, as free of the levels of passion as it was of the shadow of mortality.

Here was a "world of fantasy on canvas," docked of "all evidence of the present day, of localized time and place; it was a dream refuge made of dreams."[34] And Ernst Scheyer has provided a brief description of the attraction classical art had for those who sought a safe harbor:

This turning to the classical world was not the simple homecoming to the land in which their grandfathers' thoughts had dwelled, not solid ground, but an isolated forlorn island, lost in the ocean of ordinary life, desperately looked for, where the shipwrecked and the exiled might find shelter.

Classical art was a refuge from the burden of modern solitude, where one could escape into a timeless world and avoid the modern preoccupation with aesthetic consciousness and sensibility.[35]

In particular, for Hitler, classical art was a defense against the turbulence and lack of direction in modern art. It combatted the confusion and incongruities of Beckmann's *Dream of Monte Carlo*, *Galleria Umberto*, and *Carnival*, as it provided reasons for dismissing an artist such as Klee, who produced nonheroic and ambiguous works with such titles as *Fugue in Blue and Red*, *Three Notes Squared*, *Active Line Circumscribing Itself*, *Latticework Fence and Its Enemy*, and *Revolution of a Viaduct*. It rescued the concept of proper human relationships, which was threatened by paintings like Nolde's *Brother and Sister*, with its suggestion of some hidden obscenity, some furtive, incestuous connection, some smirking denial of the wholesome and the appropriate, as it refuted those artists such as Schlemmer with his *Roman Theme*—where the figures appeared more like inhabitants of Easter Island than like what Hitler thought of as classical personalities—and Beckmann, who had the impudence to entitle his works *Perseus*, *Odysseus and Calypso*, and *The Argonauts*, thus hinting at some relationship to classical themes.

This interpretation of classical art also pandered to Hitler's anti-Semitism, for he saw Greek and Roman art as uncontaminated by Jewish influences. Modern art was an act of aesthetic violence by the Jews against the German spirit. Such was true to Hitler even though only Liebermann, Meidner, Freundlich, and Marc Chagall, among those who made significant contributions to the German modernist movement, were Jewish. But Hitler, somewhat like his political hero of the first decade of the twentieth century, the Viennese mayor Karl Lueger, took upon himself the responsibility of deciding who, in matters of culture, thought and acted like a Jew. He had no doubt that in the area of aesthetics the Jews, supported by those who had been influenced by the Jews and were thus "internally Jewish," played their roles as the "decomposing fungi of mankind." He argued that the Jews (who lacked "the essential

requirement for a cultural people, the idealistic attitude") acted upon
the belief that the "Germans, who accept perverse pictures of the
crucified Christ, are capable of swallowing other horrors, too, if one
can persuade them that these horrors are beautiful."[36] And with the
help of "phony art critics," the Jews proposed "a conception of art
according to which the worst rubbish in painting became the expres-
sion of the height of artistic accomplishment."[37] But the classical
model, with its heroism, its harmony, and its historical monumen-
tality, protected against Jewish obscenity, dissonance, and di-
visiveness. Classical art was *Judenrein* (cleansed of Jews)—an art
where exterior form expressed the inner racial ideal.

Certainly it must be said too that Hitler, like many other
bloody-minded men, was something of a prude and responded with
hostility to the display in modern painting and sculpture of what he
thought of as crude biological functions and open sexuality. As a
young artist he had not struggled with the problem of modern eroti-
cism that had been of such concern to his contemporaries and had
reacted with anger to what Alessandra Comini, in her *The Fantastic
Art of Vienna*, describes as the themes of "death and sexuality," a
"nightmare of eros" that colored artistic life in Vienna in the years
prior to World War I. Hitler had never attempted to project an
artistic interpretation of provocative and even threatening encoun-
ters of men and women, and Otto Mueller's withdrawn nudes, those
slim, adolescent girls who daydreamed the summer away under
green trees, were as alien to him as was the aggressive sexuality of
Kirchner, whose *Self-Portrait at Dawn* shows us the haunted, melan-
choly male face pressed against a shadowy, naked female body.
Hitler was uninterested in any "apocalyptic woman" and regarded
any attempt to portray such as an example of frivolity and madness.
Beckmann's themes of binding and mutilation, of bare-breasted
women and sinister men, were as offensive to Hitler as were Max
Ernst's sexual apparitions, and as early as 1924 in *Mein Kampf* he had
complained that artistic life "today is like a hot-house of sexual ideas
and stimulations."[38]

Classical art, as Hitler saw it, had projected sensuality and
had thus provided the model for German eroticism, but this passion
had been controlled, healthy, and elevated to an idealized desire,
almost a Keatsian "Forever wilt thou love, and she be fair." Modern
art, however, was "pig art" *(Ferkel-Kunst)*, and the modern painter
had become a "filthy fellow" *(ein Schmutzfink)*. Kirchner's *Semi-Nude*

Woman with Hat could only be seen by Hitler as coarsely suggestive and prurient, while Mueller's *Couple in a Bar* had to be regarded as an illustration of pornographic bohemia at its most decadent. Dix, as in his *Girl before a Mirror*, painted hags with sagging breasts, straggling pubic hair, and hideous facial grimaces, and in his 1926 *Portrait of the Journalist Sylvia von Harden* presented those characteristics of the modern woman most offensive to Hitler: mannish features, cigarette in hand, alcohol on the table, lumpy stockings, and, undoubtedly, expressing the most dangerous, subversive thoughts. Barlach's *Loving Couple* consisted of two shapeless figures in reclining position, the man caressing the female's breast, while she looks at him with dulled expectancy. Grosz had been a principal contributor to the magazine *Everyman His Own Football*, the chief declared purpose of which was "to stamp into the mud everything which until now had been held dear to Germany," and his *Ecce Homo* has been described by Beth Irwin Lewis as a publication where:

> The drawings range over a wide scale of natural and perverse sexual activity. Lecherous uncles ogle their young nieces. Sex murderers play cards or scrub their hands after mangling their victims. Old men dream dreams. Young women experience tumescent ecstasy. Mummy and Daddy grapple in grotesque fury. Brothels abound in activities that titillate jaded senses. A foot fetishist searches for satisfaction.[39]

Here was *Bordellkunst* (the art of the bordello), an affront to what Hitler regarded as the eternal, classic, feminine principle.

Hitler extended his animosity from the painting to the painter. For him art was the expression of the moral character of the artist (as he declared, "stunted men have the philosophy of stunted men"), and what he regarded as perversion in a work of art indicated the diseased mind of its creator. He accepted the idea that *Le style, c'est l'homme même*, or, put more directly, you are what you paint, and agreed with critics such as the Swiss Alexander Senger (author of *The Crisis of Architecture* and *Moscow's Torch*, where he described Le Corbusier as the "Lenin of Architecture"), who in the nineteen-twenties and nineteen-thirties claimed that artistic decline was a morbid deviation from an original, valid model and that such deviation indicated the artist's immorality and even insanity. Artists who painted what was vicious or ugly or treasonable were stating their approval, even declaring their support, of such activity, and degen-

erate art was the true reflection of a degenerate mind. The portraits artists did of themselves and of their fellow artists showed the nature of the illness. Kirchner painted himself as *The Drinker*, a lost inebriate in the midst of chaotic surroundings. Meidner's *Self-Portrait*, with bulging eyes, underdeveloped jaw, and deformed ears, illustrated the condition of one who might easily be a pyromaniac or a child-molester. In his self-portraits Beckmann appeared as a man who might have stepped from one of his more grotesque canvases, and Felixmüller's painting of Dix showed the demented artist at work in his studio. In turn Raoul Hausmann did a head of Felixmüller with various disjointed features and the brain tissue showing. Similar distortions were present in self-portraits by Wilhelm Morgner and Ehmsen and in Kirchner's portrait of Schlemmer. The conclusion to be drawn was obvious to Hitler. One could no more allow art to be a refuge for the mentally and spiritually deranged and for those with perverted tastes than one would permit the criminal to exercise a nefarious influence upon the general society. In 1935, at the Nuremberg party rally, Hitler admitted that he regarded modern artists as "incompetents, cheats, and madmen" and announced that he had "no intention of letting these last loose upon the people." On the same occasion he declared that art must always be subject to one overriding consideration: "that it draw a true picture of life and the inborn capacities of a people and not distort them. This gives a sure clue in judging the worth or worthlessness of an art."[40]

So the heavy hand of the devoted disciple of classicism (or of what Hitler defined as classicism) was laid upon Germany, and aesthetic authenticity was provided for the Nazi movement. Richard Grunberger indicates how Hitler's idea of the classical furnished the background for the Nazi political spectacles:

> Beethoven music framed the radio addresses of Nazi leaders, and Hitler's annual pilgrimages to the Wagner shrine at Bayreuth became as much a part of the public scene as the Royal Opening of Parliament in Britain. The Reich Chancellery recalled a classic temple; new post offices were adorned with statues of naked youths clasping burning torches: a Hellenic dawn suffused the landscape of the Third Reich.[41]

Hitler advocated a posed, monumental, idealized conglomerate of bucolic innocence, classical copies, and stilted grandeur. He was personally fond of the work of Adolf Ziegler, a Munich artist whom

Hitler had selected to paint the posthumous portrait of his niece after her suicide in 1931, and he placed Ziegler's *The Four Elements* over the mantelpiece of his house in Munich. The four elements were four statuesque, female figures, posed, precise, and dead. Similarly, Ziegler's *The Judgment of Paris* shows a calm Paris examining the feminine virtues of the contending goddesses for the golden apple. Hitler was also attracted to Richard Klein, and Klein's *The Awakening Ideal* is what one would expect. A Promethean figure (Hitler had pointed out in *Mein Kampf* that the Aryan was "the Prometheus of mankind") is being called to life by some Homeric shades floating in the air. And there was Arno Breker, undoubtedly Hitler's favorite sculptor and his artistic guide in the summer of 1940 when Hitler toured a conquered Paris. Breker's *The Party* presents a magnificently muscled man bearing a torch. His *Guardian* portrays the idealized German hero in a high wind with cape and hair afloat, naked, with muscles at the strain, drawing a sword, and facing inscrutable dangers. And his *Comrades* shows again the heroic figure, again naked, again with bulging muscles and defiant face, holding up his wounded companion. Classical nudity became something of a craze in Nazi Germany, and Hellmut Lehmann-Haupt points out that nudes appeared "single and in groups, with and without stockings, with and without swans, standing, lying, symbolic, suggestive, and always with a thin veneer of prim virtue."[42]

It was, at least to some extent, her allegiance to an eternal Hellenism that attracted Hitler to the filmmaker Leni Riefenstahl, whom he called "my perfect German woman." In her films—*Victory of the Faith, Day of Freedom, Triumph of the Will*, and *Olympiad*—Riefenstahl stressed the classic grandeur, the organized power, the idealized vision of the German people. She captured on film those "eternal moments" when victory, defeat, comradeship, and pain are transformed into manifestations of the heroic will. In a 1965 interview appearing in the French magazine *Cahiers du Cinéma*, she remarked that "Whatever is purely realistic, slice-of-life, what is average, quotidian, doesn't interest me. . . . I am fascinated by what is beautiful, strong, healthy, what is living. I seek harmony. When harmony is produced, I am happy."[43] Hitler could not have expressed the point more clearly.

Even Hitler's personal art collection can be seen as his response on behalf of what he regarded as artistically valuable and in opposition to the modernist movement. According to Hitler, "the

Jews have succeeded in condemning nearly everything that was healthy in art as junk and trash"; thus, "although I hadn't much money, I began to buy." Because many collectors "were not capable of telling the difference between what was beautiful and what was ugly," Hitler regarded himself as the custodian of neglected artistic treasures. He was often to boast of his acquisitions, as when he stated that "I was able to gain possession of the admirable *Venus* by Bordone, which formerly belonged to the Duke of Kent." He was especially attracted to the landscape genre of the nineteenth century and to scenes of domestic tranquillity. He claimed, correctly, that "I have the best collection of the works of Spitzweg in the world, and they are worth anything from sixty to eighty thousand marks each. I have also paid eighty thousand marks for a Degregger."[44] Gottfried Lindemann indicates why Hitler was attracted to this type of art when he notes that "Carl Spitzweg's pictures describe the quiet happiness that flowers in seclusion far from the problems of this world" and that "The titles of his pictures, *The Cactus Lover, The Poor Poet, The Love Letter, The Lover of Books*, might just as well be titles of short stories."[45] Hitler also bought paintings by Hans Thoma, Eduard Grützner, Friedrich Stahl, Karl Leipold, and others who stressed what he thought of as the permanent virtues of German life. Lehmann-Haupt comments upon this urge for aesthetic stability: "It is the fixation upon the illusion of a secure, serene world, conspicuously formulated by the naturalistic painter of the later nineteenth century, that accounts for the static nature of the painting fostered by the totalitarian state."[46]

This collection was to be housed in a new art gallery to be built after the war in Linz, the city Hitler regarded as his boyhood hometown. Here was to be a new "Mekka" or "Rom," where landscape paintings were to be lodged in company with those examples of the Baroque and Romantic periods that expressed the great European spirit. Hitler engaged various qualified and not-so-qualified art experts to assemble the collection, and during the war these agents journeyed throughout Europe and acquired the treasures, by purchase, by forced gift, and by chicanery. Heinrich Hoffmann, an old Munich friend and the official Nazi photographer, bought seventy-seven Dutch masters for Hitler; the art dealer Karl Haberstock secured Watteau's *The Dance*, which had at one time belonged to Frederick the Great, and Vermeer's *The Artist in His Studio* (for which Hitler paid approximately $660,000); and Kajetan Mühl-

mann, a Salzburg tourist agent prior to World War I, obtained Breughel's *The Haymakers*, as well as a large number of rare coins and articles of medieval armor. The art historian Hans Posse went to the Netherlands, Belgium, and France to secure pictures for the collection, and after Posse's death Hermann Voss, author of the authoritative book *Late-Renaissance Painting in Rome and Florence* and director of the gallery in Dresden, was placed in charge of developing the Linz holdings and purchased over four thousand paintings. (As a prisoner of war in 1945, Voss testified that while Hitler did not have a deep appreciation of the art of the Italian Renaissance or of the Baroque period, he was extreme only in his hatred of modern French art, which he ordered be kept out of Germany.)[47] Over three hundred paintings came from the Rothschild collections in Vienna, while from that family's Paris branch came Vermeer's *The Astronomer*, Frans Hals' *Lady with a Rose*, Boucher's *Mme. de Pompadour in Her Boudoir*, and Goya's painting of the Soria children. By 1945, over five thousand paintings by, among others, da Vinci, Jan Steens, Tintoretto, Rubens, Ingres, and Rembrandt (including *Portrait of Titus* and *Landscape with Castle*), had been secured, as well as tapestries, pieces of sculpture, and miscellaneous items. At the conclusion of World War II Hitler's collection was valued at approximately four hundred million dollars. It has been estimated that he spent sixty-five million dollars in acquiring his holdings, and Janet Flanner, in her *Men and Monuments*, wrote that this sum was "the greatest individual outlay for beauty ever recorded, especially by a man who knew and cared nothing about it."[48] (The first part of Flanner's statement is probably true; the last part is a misleading simplification.) In his last hours, with his world collapsing about him, Hitler dictated his personal will, wherein he commented upon his recent marriage, noted his decision to commit suicide, and disposed of his belongings:

> My possessions, in so far as they are worth anything, belong to the Party, or if that no longer exists, to the State. If the State too is destroyed, there is no need for any further instructions on my part. The paintings in the collections bought by me during the course of the years were never assembled for private purposes, but solely for the establishment of a picture gallery in my home town of Linz on the Danube.[49]

Hitler's exaggerated desire to capture human experience in

frozen, clear forms—in a monumental architecture, in a homogeneous racial politics, in an ordered and unambiguous history, in an ennobling art—can be seen, at least in part, as an expression of his metaphysical insecurity. As an "outsider" he longed for the safety of a tradition, for an ideal that would provide a goal toward which action could lead, as he hungered for a cold, hard, historical center that would put an end to what he called the Germans' "feeling of forlorn loneliness." He did think that art should possess a grand style, embodied in clear definition, a rhetorical message, finish, and stability. Prior to World War I, Franz Marc had written that style, that "inalienable possession of an earlier era, collapsed catastrophically in the middle of the nineteenth century. There has been no style since. It has perished all over the world as if seized by an epidemic."⁵⁰ Hitler, however, could not accept such an argument and was convinced that the classical models could be resuscitated, that influences masking the true European spirit could be eliminated. In his view there had to be a heart to European culture, and he saw in classical art the distinctive core of the European experience, something that provided cultural continuity to European history. Thus he claimed that Germany must be not only the carrier of contemporary culture but of the preceding cultures of antiquity as well. In a speech at the 1936 Nuremberg party rally he said: "It is the belief in our people that has made us small men great, that has made us poor men rich, that has made brave and courageous men out of us wavering, spiritless, timid folk; this belief made us see our road when we were astray; it joined us together into one whole."⁵¹ And this belief was to be expressed in an art that avoided anything "Oriental and Semitic," in an art that could resist the cultural decomposition threatened by the Jewish-Bolshevik, capitalist, liberal conspiracy.

Because he took differences with modern artists so seriously, Hitler regarded any controversy with them as one that called for measures appropriate to military conflict. When he laid the foundation stone for the congress hall in Nuremberg, he said to Hans Frank: "I am building for eternity, for, Frank, we are the last Germans. If we were ever to disappear . . . there would be no Germany any more."⁵² He believed that if the German people failed in their struggle with what he thought of as the riffraff of the world, then such a result would indicate that Germany was too weak to face the test of history and deserved destruction. Here are expressions of a

life-and-death struggle, not trivial arguments over mere aesthetic or historical preferences. There is no evidence that Hitler ever allowed the slightest doubt to enter his mind. His response to aesthetic and political opposition was: smash the enemies! By an exercise of will and force he thought that he could reverse the direction of art and impose upon Germany what Barlach truly described as those "miserable, monotonous accuracies, states of a miserable, monotonous nakedness of male and female, offerings lacking in consolation."[53] Race was destiny, and art was destiny, and there was to be no distracting confusion in the German view of this national future. Hitler never made a journey to Greece—although he could easily have done so—and he never saw the Parthenon or the Acropolis. But his vision was not dependent upon the actual material itself but upon what he saw with his inner cultural eye. Here all was clear and ordered, without anxiety and without ambiguity, an expression of the idealistic German will and the last hope of a true European community.

5

THE EXHIBITION OF DEGENERATE ART

"My pictures are scorned, sold off for a song.
I watch with eyes closed.
Their colors still glow in the darkness."

Emil Nolde[1]

It was appropriate that the most dramatic expression of the conflict between Adolf Hitler and the modern artists should occur in Munich. The Nazi party had been born in Munich, and the city was identified with Hitler's early political career. In his will of May 2, 1938, he ordered that, upon his death, his body be taken to Munich—to lie in state in the Feldherrnhalle and then to be buried nearby. More than any other place, Munich was home to him, and in *Mein Kampf* Hitler described the city as "this metropolis of German art" and stated that "one does not know German art if one has not seen Munich." And he wrote of the impact Munich had had upon him when he arrived there as a young man: "I was attracted by

95

The House of German Art in Munich.

this wonderful marriage of primordial power and fine artistic mood, this single line from Hofbräuhaus to the Odeon [Munich's principal concert hall], from the October Festival to the Pinakothek [the Museum of Art]."[2] In 1913–14 he had made his living in the Bavarian city as a painter, earning approximately 100 marks a month from the sale of his work (at the time a bank clerk would have received a monthly salary of 70 marks), and there he painted some of his best-known pictures—*Hofbräuhaus I, Hofbräuhaus II, Old Courtyard, Old Town Hall, The Registry Office.* (One of Hitler's Munich watercolors, *Old Hofbräuhaus,* was offered for sale in 1970 for 30,000 marks.) In October 1933, in a ceremony accompanied by a parade of contingents of the Hitler Youth, the SA, and the SS, and the playing of the Prelude to *Die Meistersinger,* Hitler endowed Munich with the title "Capital City of German Art" ("the capital of art and of our movement is and will ever remain Munich") and laid the cornerstone for what was to become the House of German Art. He undoubtedly expected the new structure to replace the famous Glaspalast, built in 1854 and located in the Botanical Garden, which had been destroyed by fire in June 1931, during a showing of German Romantic painting.

But Munich had also been the seedbed of the modernist movement in Germany in the decade and a half preceding World War I, and the city attracted students from all over the world, including the American Albert Bloch, who was born in St. Louis, came to Munich in 1908, participated in the Blue Rider exhibitions, and returned to the United States in 1921. Ernst Kirchner studied art in Munich, as did Gabriele Münter and Marianne von Werefkin, who, at a time when none of the traditional art academies in Germany would admit women, found a hospitable environment in the Bavarian capital. Paul Klee, Vassily Kandinsky, Alexei von Jawlensky, August Macke, and Franz Marc were all associated with the city. The *Blue Rider Almanac* was published in Munich, and Schwabing, the artists' section, was described by Kandinsky as "that slightly comical, more than slightly eccentric and self-assured place where anyone, man or woman, who was not carrying a palette or a canvas or at the very least a portfolio, was immediately conspicuous, like a 'foreigner' in a small country village." In 1966, as a voice from the far past, Vladimir von Bechtejeff was to write from the Soviet Union of "Munich 1902–14—time of my youth, of my hopes, of my first venture into art" and to speak of "the spirit of winged gaiety, uncon-

The cover of the catalog for the Exhibition of Degenerate Art. The stone head was by Otto Freundlich, who perished in a German camp during World War II. Franz Roh, *"Entartete" Kunst. Kunstbarbarei im Dritten Reich* (Hannover: Fackelträger Verlag, 1962).

strained openness, and goodwill that I found in Munich's artistic circles."[3] After World War I, Berlin became preeminent as a center for German art, but it was in Munich that there appeared in the early part of the twentieth century what Marc called "those beautiful, strange exhibitions that drove critics to despair."

In the years following 1933, Adolf Hitler worked closely with the architect Paul Troost in designing the House of German Art, consulting frequently with Troost and, after Troost's death, with his widow and others involved in the project. By the spring of 1937 the building was completed, and plans were made for a dedication ceremony that would establish the new museum as the center for official, Nazi-approved art. However, an undertaking that was intended to complement the dedication of the House of German Art and to illustrate the health and vigor of Nazi aesthetic perception provided a dramatic and unexpected turn to the events of that summer. Since 1933 local Nazi authorities had staged what were called exhibitions of degenerate art or exhibitions of shame *(Schandausstellungen)* in Karlsruhe, Stuttgart, Mannheim, Dresden, Nuremberg (where the museum established a "Chamber of Horrors" for the showing of modern art), and other cities where the public was given the opportunity to gawk at what were described as salacious and shocking paintings and sculpture. Several of those interested in such public education, including Walter Hansen and Wolfgang Willrich, who was to publish a book entitled *Cleansing of the Temple of Art* later in 1937, began to organize such an exhibition to coincide with the opening of the House of German Art and thus illustrate the artistic evils from which Germany had been rescued. Initially there was some controversy among Nazi officials as to the advisability of staging such an event, but on June 30 the painter Adolf Ziegler, who had been appointed president of the fine arts section of the Chamber for Arts and Culture in 1936, was authorized by Hitler and Goebbels to prepare an exhibition and to "select works of decadent art in the sphere of painting and sculpture since 1910 from those in the possession of state, provincial, and municipal authorities."[4] Ziegler and his staff acted with alacrity, and within two weeks had collected some seven hundred works from twenty-five museums.

On July 18, 1937, the House of German Art opened. Eight hundred and eighty-four paintings and pieces of sculpture were on exhibit, including works by such Nazi favorites as Arno Breker, Josef Thorak, Richard Klein, and Ziegler. There were portraits of

Hitler and Goebbels visiting the Exhibition of Degenerate Art on opening day, July 19, 1937. Franz Roh, *"Entartete" Kunst. Kunstbarbarei im Dritten Reich* (Hannover: Fackelträger Verlag, 1962).

Hitler and architect Troost, as well as Hermann Hoyer's *In the Beginning Was the Word*, an idealized picture of Hitler addressing a group of fellow Nazis during the early days of the party. The works on display were absolutely without aesthetic distinction, and, although competition in this category was extreme, perhaps the most sterile piece was Elk Eber's painting *The Call to Arms*, a portrayal of two block-headed, stone-faced Nazis who are preparing themselves for a little ear-pounding and groin-kicking in the streets. An art critic, writing for a German newspaper and observing carefully the official injunction against speculative criticism, remarked that the paintings showed "fresh, sun-tanned maidens," women "offering their well-rounded breasts to infant children," families "gathered around the cradle in merry domesticity." The entire exhibition thus appealed "to the innermost feelings and moods of the German people."[5] Richard Grunberger, commenting some thirty-five years after the event, provides an excellent summary:

> Every single painting on display projected either soulful elevation or challenging heroism. . . . All the work exhibited transmitted the impression of an intact life from which the stresses and problems of modern existence were entirely absent—and there was one glaringly obvious omission—not a single canvas depicted urban and industrial life.[6]

The important attraction of the opening ceremonies of the House of German Art was not, however, the exhibition of works. Attention was directed to Adolf Hitler, now at the height of his power, with all internal opponents defeated and with his international triumphs before him, who had come to Munich to declare his victory in the area of art. In 1933, when Paul Klee arrived as a refugee in Switzerland, he remarked: "Here I am, there is no place for me in Germany." Hitler now stood in the House of German Art, amidst the carefully arranged examples of heroism and national virtue and surrounded by faithful followers, as verification of Klee's statement. And he spoke of his conquest. What he called a "turning point" in German art was being observed in Munich. For an hour and a half he assured his listeners that cultural collapse had been arrested and that the vigorous classical tradition had been resuscitated: "Never was humanity in its appearance and its feelings closer to classical antiquity than today," he declared. The "flood of slime and ordure" loosed upon Germany by degenerate artists had

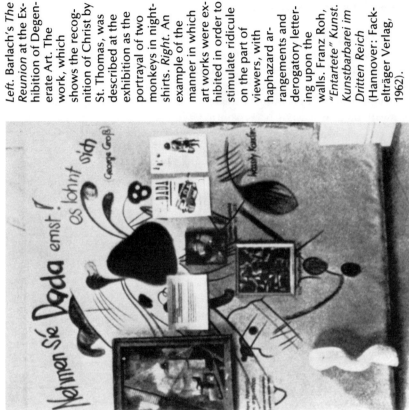

Left. Barlach's *The Reunion* at the Exhibition of Degenerate Art. The work, which shows the recognition of Christ by St. Thomas, was described at the exhibition as the portrayal of two monkeys in nightshirts. *Right.* An example of the manner in which art works were exhibited in order to stimulate ridicule on the part of viewers, with haphazard arrangements and derogatory lettering upon the walls. Franz Roh, *"Entartete" Kunst. Kunstbarbarei im Dritten Reich* (Hannover: Fackelträger Verlag, 1962).

been dammed, and the House of German Art was being dedicated as a "temple, not for a so-called modern art, but for a true and everlasting German art."

The greater part of Hitler's dedication address was a repetition of his previous attacks upon modern art. Again he denied that art could be "an international communal experience" or that there existed artistic periods or styles. Art was not an activity similar to "the handiwork of our modern tailor shops and fashion industries," answering the challenge: "Every year something new. One day Impressionism, then Futurism, Cubism, and maybe even Dadaism." No, art "is not founded on time, but only on peoples. It is therefore imperative that the artist erect a monument not to a time but to his people." As there are eternal racial groupings, so there must be an eternal racial art, which speaks today as it spoke yesterday, and as it will speak tomorrow. As long as the German people exist, their art—in which they see themselves and to which they respond—is "the fixed pole," secure and lasting, no matter the "fleeting appearances" of life. The Germans demand "an art that reflects their growing racial unification and, thus, the portrayal of a well-rounded, total character." They seek the eternal, not the transitory, in art as in history.

Hitler also again stressed what he regarded as the principal characteristic of true German art, or what he called not a definition or an explanation but a "law." As he said, "The most beautiful law which I can envisage for my people" is: "To be German is to be clear." Other races might have other aesthetic longings, but "this deep, inner yearning for a German art that expresses this law of clarity has always been alive in our people. It occupied our great painters, our architects, our thinkers and poets, and, probably to the highest degree, our musicians." Artists do not create for other artists or for art critics. Art is for the people, and the artist must present what the people see—"not blue meadows, green skies, sulphur-yellow clouds, and so on." There can be no place for "pitiful unfortunates, who obviously suffer from some eye disease," and such will not be allowed to "foist these products of their misrepresentation upon the age in which we live, or to present them as art."

And Hitler declared that, in art as in politics, he was prepared "to rid the German Reich of those influences which are fatal and ruinous to its existence." He promised that he would continue to "wage an unrelenting war of purification against the last elements of

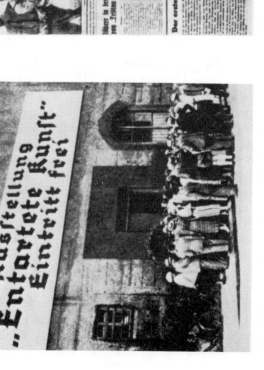

Left. Visitors waiting to be admitted to the Exhibition of Degenerate Art. The sign above the door indicates that there is no admission charge. *Right.* The front page of the official Nazi newspaper, *Völkischer Beobachter,* for July 17, 1937. The headline announces that the opening of the House of German Art is "The Hour of Rebirth of German Art." Franz Roh, *"Entartete" Kunst. Kunstbarbarei im Dritten Reich* (Hannover: Fackelträger Verlag, 1962).

putrefaction in our culture," that "all these cliques of babblers, dilettantes, and art crooks will be eliminated," and that what he called "claptrap or jabbering," these "mendacious excuses," would "no longer be accepted as defenses for worthless, integrally unskilled products." He announced that he had "come to the unalterable decision to clean house, just as I have done in the domain of political confusion, and from now on to rid German art life of its phrasemongering." The House of German Art had been built by the German people as a home for true German creative effort, and "with the opening of this exhibition the end of German art foolishness and the end of the destruction of German culture will have begun."[7]

So spoke the leader of the people. And a properly respectful audience filed past the works of art; pictures of Hitler (some later modified by skillful photographic technicians to show him in more dramatic poses) appeared in the press; and all published comment upon the House and its contents was favorable. The next day, July 19, the Exhibition of Degenerate Art opened. Located in the annexes of the Municipal Archaeological Institute, the exhibition included works by one hundred and twelve artists—German and non-German. Twenty-seven of Nolde's paintings (including his *Life of Christ* altarpiece), eight by Dix, thirteen by Erich Heckel, sixty-one by Schmidt-Rottluff, and seventeen by Klee were here in company with thirty-two by Kirchner, including his *Self-Portrait as a Soldier, Königstein Train Station,* and *Winter Moon Landscape.* Lehmbruck's *Kneeling Woman* was on show, as were Beckmann's *Carnival in Paris* and *Self-Portrait in Dinner Jacket,* Lovis Corinth's *Ecce Homo,* and Marc's *Tower of Blue Horses.* (There appears to have been some complaint at the inclusion of Marc's works in the exhibition. Marc had been killed at Verdun in 1916 and thus had a claim to the status of German war hero.[8]) On view was the plunder of the Folkwang Museum in Essen, the National Gallery in Berlin, and Germany's other leading museums and galleries. Work by non-Germans on exhibit included Gauguin's *Riders on the Sand* and Picasso's portrait of the Soler family.

The tone of the exhibition was set by Ziegler, who, in his address opening the showing, alerted his audience to what was in store: "You see about you the products of insanity, of impudence, of ineptitude, and of decadence." He encouraged his listeners not to hide their shock and dismay, and he attacked those who had been responsible for German museums, squandering public funds on

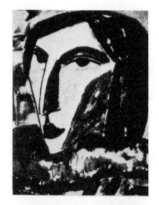

A page from the catalog for the Exhibition of Degenerate Art announcing a "very instructive racial cross-section," wherein the similarity of portraits by modern artists to non-German peoples illustrates the degenerate nature of those attracted to such models. Franz Roh, *"Entartete" Kunst. Kunstbarbarei im Dritten Reich* (Hannover: Fackelträger Verlag, 1962).

such "monstrosities" while disregarding the efforts of "true" German artists. "It is a sin and a shame that the institutes are filled with such trash while honest and sincere artists are ignored," he declared. Then, with a dramatic flourish, he announced: "Let the German people decide! We have no fear of their verdict!"[9]

In hanging the exhibition, Ziegler and his associates outdid themselves, and there is some second-hand evidence that even Hitler, when he visited the showing on opening day, was taken aback by the way in which the exhibition was presented.[10] Paintings and pieces of sculpture were placed so as to make them appear crude and incomprehensible. Haphazard arrangements and derogatory lettering upon the walls—running over, under, and around pictures—were designed to stimulate ridicule. Many of the paintings had explanatory statements to indicate the nature of the works. Thus Kirchner's *Peasants at Midday* was identified as "German peasants as seen by the yids"; Max Ernst's *The Creation of Eve or The Fair Gardener* was shown with the explanation "insult to German womanhood"; work by Dix was labeled "military sabotage"; Schlemmer's *The Passerby* carried the title "Bolshevism without a Mask"; and Barlach's statue *The Reunion*, a portrayal of the recognition of Christ by Saint Thomas, was described as "two monkeys in nightshirts."

In order that none of those attending the exhibition should fail to receive the message, what may have been the most outlandish catalog ever published was made available. The cover of the publication carried the words "Degenerate Art" and a photographic reproduction of *L'Homme nouveau*, a stone head by Otto Freundlich, who had departed Germany after Hitler came to power and who, after the defeat of France in 1940, was to be arrested and placed in a concentration camp, where he perished. The contents of the catalog consisted of turgid and inflammatory pronouncements about modern art, quotations from Hitler's speeches, and reproductions of works illustrating modern degeneracy. The introduction promised the visitor to the exhibition that he or she would gain a clear idea of the reasons for the cultural decline of Germany prior to 1933. The close connection of political and cultural anarchy was stressed, and the Jewish and Bolshevik threat to German values was indicated.

The exhibition was divided into nine groups or categories with paintings and sculpture chosen to illustrate each of these, and the catalog provided what could be called a running commentary. The first category consisted of works portraying the distortion of

„Offenbarungen deutscher Religiosität"

hat die den jüdischen Kunsthändlern feile Presse einmal solchen Hexenspuk genannt.

Die Titel lauten:

„Christus und die Sünderin", „Tod der Maria aus Ägypten", „Kreuzabnahme" und „Christus". Die „Künstler" heißen: Nolde, Morgner und Kurth.

Illustrations from the catalog indicating how works by Nolde, Morgner, and Kurth violate German religious attitudes. Franz Roh, *"Entartete" Kunst. Kunstbarbarei im Dritten Reich* (Hannover: Fackelträger Verlag, 1962).

form and the misuse of color. The second group was devoted to examples of the ways in which modern artists mocked religious feelings and attempted to confuse the people as to the nature of religious experience. The third showed art that stimulated political anarchy, saying, "Each picture in this group advocates the Bolshevik class struggle." Group four showed work that ridiculed the deep respect Germans had for "military virtue, courage, and willingness to serve." The fifth category provided what was termed "an insight into the moral side of degenerate art," and a visitor could see the art of those for whom the world was "one great bordello" and painting an exercise in pornography. Group six identified the Marxist and Bolshevik bent of modern artists who proposed to substitute the Negro and South Sea Islander for the Aryan model. The seventh group illustrated the interest of modern artists in idiots and cretins and showed how such an interest indicated the true decadent nature of the artists. The eighth category consisted of works by Jewish artists. The final group contained works collected under the general title "Utter Madness," and, as the catalog noted, works of this nature required the largest room in the exhibition. Here were examples of "spiritual sickness," the artistic blindness that led artists to support various "isms." The viewer was encouraged to examine three black lines painted on a piece of wood and portraits where the artists apparently could not decide whether eyes were red, blue, green, or yellow. And the catalog suggested that the only proper response was to shake the head and laugh. The publication ended with an excerpt—carrying the heading "The End of Cultural Bolshevism"—from Hitler's speech opening the House of German Art.[11]

In terms of public attendance, the Exhibition of Degenerate Art must be declared a success. In four months the showing attracted over two million visitors. (How many of these came out of curiosity, to scoff, or to take a last look at a disappearing art is impossible to determine.) After its closing in Munich, the exhibition became a traveling roadshow, appearing in Berlin and other German cities and, after the *Anschluss*, in Vienna.[12] Any protest against the exhibition was ineffectual. Nolde wrote to Goebbels and demanded that "the defamation against me cease,"[13] and Schlemmer, in a letter to the director of the state gallery in Stuttgart, complained that "it is not clear to me why I was grouped in Munich among the degenerate, destructive, fundamentally and intentionally malicious painters."[14] Neither letter was answered. In July 1938, one year after the opening of the Munich exhibition, an attempt to respond to the Nazi

Die Dirne wird zum sittlichen Ideal erhoben!

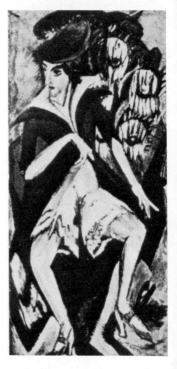

Was die bolschewistische Jüdin Rosa Luxemburg an der russischen Literatur besonders liebte: „Die russische Literatur adelt die Prostituierte, verschafft ihr Genugtuung für das an ihr begangene Verbrechen der Gesellschaft..., erhebt sie aus dem Fegefeuer der Korruption und ihrer seelischen Qualen in die Höhe sittlicher Reinheit und weiblichen Heldentums."

Rosa Luxemburg in „Die Aktion" 1921.

Here readers of the Degenerate Art catalog are alerted to the fact that modern artists have elevated prostitution to a moral ideal. The attached text attempts to show a relation of this artistic tendency and the influence of the Jews and Russian Bolshevism. Franz Roh, *"Entartete" Kunst. Kunstbarbarei im Dritten Reich* (Hannover: Fackelträger Verlag, 1962).

extravaganza was made in London. There, for one month, a show-
ing in the New Burlington Galleries displayed works by Kandinsky,
Feininger, Klee, Ernst, Marc, Macke, Beckmann, Dix, Grosz,
Pechstein, Schmidt-Rottluff, Kirchner, Schlemmer, Kollwitz, and
Nolde, all secured from private collections outside Germany and—
understandably—often without the artists' consent. Beckmann, who
was then living in Amsterdam, made a personal appearance and
delivered a lecture, "On My Paintings," in which he argued that
while artistic creativity and political realities were connected, they
were governed by separate laws. But the entire effort aroused little
interest in the British public. Hitler dismissed the undertaking with
the comment that the London show illustrated very well "the con-
trast between the cultural greatness of an earlier period and the
poverty of German art today." He was also quoted as having said
that "business interests were at work. But in any case he supposed
that somebody had to beat the drum on behalf of the Bolshevik
government."[15] Perhaps the most belated, even bizarre, response to
the Munich spectacle was by Max Ernst, whose *The Creation of Eve or
The Fair Gardener* was displayed at the Exhibition of Degenerate Art
and then destroyed. In 1967 Ernst remarked: "That the Nazis de-
stroyed *The Fair Gardener* continued to infuriate me to such a pitch
that I could finally no longer resist the temptation to make a new
version."[16] And he repainted the picture with the title *The Return of
the Fair Gardener*.

 The year 1937 was the climax of Hitler's quarrel with the
modern artists. From that time the pressure was never relaxed. As
he was to say in March 1942: "When I visit an exhibition, I never fail
to have all the daubs pitilessly withdrawn from it. It will be ad-
mitted that whoever visits the House of German Art today will not
find any work there that isn't worthy of its place. Everything that
hasn't an undeniable value has been sieved out."[17] On the day the
Exhibition of Degenerate Art opened, Beckmann departed Ger-
many, never to return, while that same month Feininger, who had
been born in New York of German immigrant parents and who had
lived in Europe since 1887, took advantage of his American passport
and journeyed to the United States. Barlach, Nolde, Pechstein,
Schmidt-Rottluff, and Kirchner, who had previously refused invita-
tions to resign from the Prussian Academy of Arts, were expelled.
Carl Hofer was made an "inactive" member and then expelled in
1938. Heckel was denounced as a decadent and denied the right to
exhibit, and Karl Caspar was dismissed from the Academy of Fine

Gemalte Wehrsabotage
des Malers Otto Dix

The work of Otto Dix is used in the catalog to show how modern artists act as subversive agents and project a lack of patriotic feeling. Franz Roh, *"Entartete" Kunst. Kunstbarbarei im Dritten Reich* (Hannover: Fackelträger Verlag, 1962).

Arts in Munich. The purging of modern art was undertaken with renewed vigor. In a fresh wave of activity, more paintings, prints, and drawings were removed from museums and galleries. Such confiscations were given legal standing by the retroactive Degenerate Art Law of May 1938, which stated that "products of degenerate art that have been secured in museums or in collections open to the public before this law went into effect . . . can be appropriated by the Reich without compensation." The law also indicated that "the Führer and Chancellor of the Reich has ordered such appropriation. He will have authority over items that become the property of the Reich."[18]

The Nazis also decided to dispose of for cash those art works thought too offensive to be allowed to remain in Germany and for which there were prospective purchasers. A Commission on the Value of Confiscated Works of Degenerate Art was established in order to expedite the sales to foreigners, and arrangements were made with the Galerie Fischer of Lucerne for an auction. On June 30, 1939, the sale took place in the Swiss city, and one hundred and twenty-five pictures were sold. Dealers from outside Germany paid $21,000 for Van Gogh's *Self-Portrait* (now in the Fogg Museum at Harvard University), $10,000 for one of Picasso's harlequin paintings, and slightly more than $9,000 for a Gauguin Tahiti landscape. Franz Marc's *Fate of Animals*, which in 1936 had been removed from the Moritzburg Museum in Halle, was purchased by the Basel Kunstmuseum. James Ensor's *Mask and Death* and Marc Chagall's *Winter, Blue House*, and *Rabbi* were also sold. But sales of paintings by German artists did not bring large sums into the Nazi coffers, and the prices paid were disgraceful. Klee's *Roadside House* was purchased for $200; Beckmann's *Masked Ball* for $220 and his *Self-Portrait* for $120.[19] In all, seventy-five works by Dix, Feininger, Hofer, Klee, Kirchner, Nolde, Pechstein, Beckmann, and Schmidt-Rottluff were sold for insignificant amounts. A large number of works found no buyers, and these were returned to Germany, where some four thousand paintings, prints, and drawings were destroyed in a bonfire, presided over by the Berlin fire brigade.

The House of German Art, that museum of official rectitude and yea-saying, continued to receive Hitler's steady support. Three large exhibitions were held in 1938 and 1939, and Hitler appeared on all three occasions and opened the festivities in each case with an address. In 1938 he told his audience that:

Jeder Kommentar ist hier überflüssig!

Die „Werke" stammen von Voll, Kirchner, Heckel, Hoffmann und Schmidt-Rottluff.

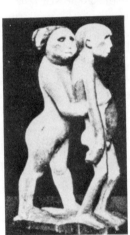

"Any comment is superfluous!" Work by Kirchner, Heckel, Schmidt-Rottluff, and others shows that the vision of the human form possessed by modern artists is so repulsive as to arouse disgust on the part of the readers of the catalog. Franz Roh, *"Entartete" Kunst. Kunstbarbarei im Dritten Reich* (Hannover: Fackelträger Verlag, 1962).

The German people of this twentieth century is a people of a newly awakened affirmation of life, seized with admiration for strength and beauty and therefore for that which is healthy and vigorous. Strength and beauty—these are the fanfares sounded by this new age; clarity and logic dominate its effort.

And he stressed again the direction artistic activity in Germany should take:

> I therefore decided to make a clean break and to set one task and one task only for our new German art. I would force it to hold to the direction the National Socialist revolution has marked out for our new national existence. . . . It is as difficult to know now as it has always been whether we have artistic geniuses of lasting stature working among us. . . . But we do know that we have created the conditions under which great genius can flourish. . . .[20]

In 1939 he claimed with satisfaction that as "political malcontents" had been eliminated, so, too, "cultural malcontents" had been swept from Germany. And the House strictly abided by the aesthetic standards that Hitler was to set forth so brutally in July 1942:

> I have inexorably adhered to the following principle. If some self-styled artist submits trash for the Munich exhibition, then he is a swindler, in which case he should be put in prison; or he is a madman, in which case he should be in an asylum; or he is a degenerate, in which case he must be sent to a concentration camp to be "reeducated" and taught the dignity of honest labor. In this way I have ensured that the Munich exhibition is avoided like the plague by the inefficient.[21]

Annually, after 1937, catalogs entitled *The Great German Art Exhibition in the House of German Art* were published. These catalogs contained photographic reproductions of what had been available for German audiences each year, and we have military scenes, portrayals of farmers' lives, realistic but romanticized war memorials, and nudes by such mediocrities as Carl Schwalbach, Constantin Gerhardinger, Karl Storch, and Werner Peiner. And, of course, by Adolf Ziegler, who exhibited his *The Goddess of Art.* The 1938 catalog even included a photograph of a painting of a brooding Zarathustra, complete with eagle, cloud-filled skies, withered tree, and weathered cliffside. There was also a picture of Emil Hub's bust of Hitler—stern, firm, and fearless. Lehmann-Haupt well describes the type of art that found shelter in the House of German Art:

There were portraits of generals with uniforms studded with decorations, abbots with crosses, romantic seascapes, genre painting of nineteenth-century life in the provinces, peaceful cattle grazing among the willow trees on the plains or on the mountain slopes; there were peasants in the fields, pictures of sunshine filtering through the leaves, peasants saying their prayers at mealtime, peasants plowing, peasants in their Sunday best.[22]

The 1939 catalog contained as a frontispiece a photograph of Hitler in military uniform and with the legend "The Protector of the House of German Art," and this photograph appeared in all subsequent annual issues. So it went, year after year, pictures of Hitler, more Venuses, more swans, more sturdy German faces. After 1941, the heroic, struggling German soldier became a prominent theme, but usually cast as a faraway character holding up the sky in some strange corner of the world. The House of German Art remained a protected, secluded refuge for a certain type of German dream. The last catalog was published in 1944. Reality was breaking in upon the true believers, and the show was coming to an end.

6

MODERN ART
AND
MODERN HISTORY

*"In the twentieth century we shall live among strange faces,
new pictures, and unheard-of sounds."*

<div align="right">

Franz Marc[1]

</div>

The important participants in the controversy between Adolf Hitler
and the artists have disappeared. Ernst Kirchner committed suicide
in 1938, and Christian Rohlfs and Ernst Barlach died that same year.
In 1940 Paul Klee lost his struggle with sclerodermia and died at
Locarno—one day before his long-standing application for Swiss
citizenship was approved. Oskar Schlemmer died in Baden-Baden in
1943 (the final entry in his diary for that year was a quotation from
the poet Rainer Maria Rilke: "to consider art not a piece plucked out
of the world, but the complete and utter transformation of the world
into pure joy"), and Käthe Kollwitz in Moritzburg near Dresden in
the spring of 1945, ten days before Hitler killed himself in Berlin. In
her last letter, dated April 16, 1945, she wrote: "The war accom-

panies me to the end." Those artists who survived Nazi persecution and the war are also gone. Some died in foreign lands: Max Beckmann, who came to the United States in 1947, of a heart attack on the corner of New York's 69th Street and Central Park West in 1950, Lyonel Feininger also in New York City in 1956, and Heinrich Campendonk in Amsterdam in 1957. Others ended their days in Germany: Max Pechstein and Carl Hofer in 1955, Emil Nolde—his last years strained by arguments over his earlier support of the Nazis—in 1956, George Grosz, who returned to Germany after World War II, in 1959, Otto Dix in 1969, Erich Heckel in 1970, and Karl Schmidt-Rottluff in 1976.

The triumphant art works remain, in Munich, Berne, Cologne, Berlin, New York, Detroit, and other cities. Although countless oils, watercolors, drawings, and prints were destroyed by the Nazis and by the disasters of war (including Franz Marc's *Tower of Blue Horses* and Heckel's *Ostend Madonna*, which has been described as "the only twentieth-century painting of the Madonna of real validity"), enough are left to carry the message directly from artist to viewer. August Macke's slender women still look away from us, into shop windows, across lakes, through the trees. Nolde's landscapes glow undiminished. In his early etchings *(Virgin in a Tree* and *Two Men Meet, Each Supposing the Other to Be of Higher Rank)* as in his last paintings *(Prisoner, Drummer, Death and Fire)*, Klee continues to intrigue and captivate. Marc has been dead for over sixty years, yet his animal pictures and his abstractions appear as fresh as if they had been painted only yesterday. Kirchner's streets and tramlines and mountains glitter, and Beckmann's triptychs entice and disturb as we struggle to master their detail and meaning.

And what of Adolf Hitler and his commitment to a heroic, racially idealistic art? His aesthetic judgments appear to us as trite, superficial, and sterile, the vulgar expostulations of a know-it-all, the bombast of a bully. How pathetic are his cliches as he strains to express himself, to speak with profundity of matters great and small. With what have been called his "ferocious metaphysical ambitions," he did stimulate a caricature of culture, what Gottfried Benn—after he had been jarred awake as to the true nature of Nazism—described as "nothing but a vacuum of historical twaddle, crushed education, bumptious political forgeries, and cheap sports." All those official and semiofficial busts and portraits of Hitler are merely historical curiosities without aesthetic value, and only the artistic response on

behalf of his victims arouses interest. In a manner true of no other important historical figure in modern European history, what could be called acceptable memorials to Hitler are inevitably protests against his existence. At the site of the extermination camp at Treblinka, a long row of railway ties done in concrete and a matching rough cobblestone replica of the prisoners' walk to death stretch into the distance and disappear into nothingness. There is Ossip Zadkine's *Destruction of the City* memorial in Rotterdam, that great shout of pain and outrage directed at the sky, as there are Gerhard Marcks' memorial in the cemetery in Frankfurt and Glid Nandor's sculpture at Dachau. There is the monument near Zagreb, in remembrance of the intellectuals—defined by the Germans as those with the equivalent of a secondary-school education—who were hanged one cold December morning in 1942. In the Père-Lachaise cemetery in Paris the bronze figure of a man rising from the barbed-wire prison and suspended against the sky reminds us of those French citizens who died at Oranienburg and Sachsenhausen. Even more simple mementos might qualify as an artistic answer to Hitler. Among the pathetic remnants discovered at Auschwitz was a dented tin bowl out of which some prisoner had apparently eaten his thin gruel. Someone had scratched on the side of the bowl a picture of a small boat riding on the waves. Beneath the sketch, in English, were the words: "Don't forget the forlorn man."

Hitler's basic ideas about art are easily grasped and can be, without undue simplification, reduced to a few statements that need little explanation. In *Discovering the Present: Three Decades in Art, Culture, and Politics*, Harold Rosenberg puts the matter nicely in one sentence devoted to the art promoted by Hitler: "The heroic figures of Nazi painting and sculpture bear the features of a peevish emptiness that seems aggressively directed, like Nazi politics itself, against every fact and idea of the twentieth century."[2] Hitler spoke more about art than has any other political figure in modern Western history. Yet there is a "peevish emptiness" in all these words, and his defense of classical art is as barren as is his attack upon modern art. If one might borrow and slightly modify a comment by Vladimir Nabokov, Hitler's interpretation of art is as interesting as a snore in the next room.

The importance of Hitler's controversy with modern artists is, thus, not related to any argument over aesthetic values. Here the evidence is in, and the shock of the modern is no longer shocking.

Rather, the significance of the quarrel is to be found in the dramatic way in which Hitler's animosity toward modern art illustrated the crisis in what can be called the historical and cultural consciousness of the West. The philosopher Karl Jaspers accurately described modern science as a deep cleft carved into human history, and Jaspers' statement could also be applied to modern art, which has acted as a hot knife separating our past ideas of aesthetic propriety from our present understanding of and response to painting and sculpture. The German art historian Hans Konrad Roethel has argued persuasively that the basis of what we think of as modern art was Nietzsche's declaration, "Who wishes to be creative must first blast and destroy accepted values." And there is substantial evidence that those German artists associated with the modernist movement were aware that they had to act as antagonists of accepted traditional values. In 1911 Marc wrote to Macke: "We must be brave and turn our back on almost everything that until now good Europeans like ourselves have thought precious and indispensable." Only then would it be possible to "escape from the exhaustion of our European bad taste."[3] In 1920, in his "Creative Credo," Beckmann wrote in the same fashion: "I certainly hope that we are finished with much of the past. Finished with the mindless imitation of visible reality; finished with feeble, archaistic, and empty decoration, and finished with that false, sentimental, and swooning mysticism."[4]

This break with the past was much more than a quarrel over form, although twentieth-century abstraction did demand a unique type of intellectual and emotional response. Modern art rendered obsolete words such as *fate*, *destiny*, and perhaps even *history* when speaking of painting and sculpture and suggested that aesthetic activity was not a matter of social and political order, was not even an articulation of common human experience. Art could no longer be, as many nineteenth-century critics had argued, an interpretation of nature and of human striving that would encourage us to aspire to physical and moral perfectibility. Only by chance could a painting or a piece of sculpture stir our cultural memories, remind us of some moving episode from the past, provide consolation for our defeats and disappointments. Art became increasingly free of religious, national, and racial connections, and art criticism was divorced from nonaesthetic values. Art could no longer express binding covenants or contracts and could not project any interpretation of a lasting, harmonious relationship of the individual and his or her environ-

ment. What could be called the common vocabulary of Western culture became outdated, and statements about the image of man, the aesthetic thread tying one generation to the next, and the essentials of the human condition became largely meaningless. Art could no longer provide cultural security, and it could no longer spiritualize the ordinary and thus introduce elevating dignity and harmony into the clutter of life.

In particular, modern art struck at the heart of German historical perceptions. German historical thinking had been to a significant extent colored by certain aesthetic judgments, by the conviction that history and art were, if not identical, then at least parallel developments, mirroring each other and providing mutual nourishment and justification. Jakob Burckhardt had put the matter directly: "Without art we should not know that truth exists, for truth is only made visible, apprehensible, and acceptable in the work of art."[5] And, as Hayden White writes in *Metahistory: The Historical Imagination in Nineteenth-Century Europe:* "For what was at issue throughout the nineteenth century, in history as in both art and the social sciences, was the form that a genuinely 'realistic representation of historical reality' ought to take."[6] For many, to be German—in art as in history—was to be, as were those sculpted figures of Ekkehart and Uta on the Naumburg Cathedral, "solid and strong, proud and dignified," and art was an expression of the German "deep longing for truth," an exercise in communal celebration. German historians from Hegel to Spengler had stressed the necessity of an aesthetic form, a brilliantly glowing structure that gave meaning to the succession of generations, provided verification of fraternity, and illuminated the destiny and fate of the race. Art held the world together and protected against disenchantment, distress, and ultimate despair. German historical thinking had been since the early nineteenth century basically a conservative exercise, an attempt to confine the thrust of what appeared to be a wayward and indiscriminate modernity. The search for order was a consuming passion with both liberals and conservatives, radicals and reactionaries, historians of the left and right. And the belief that art must present some valuable, rich, sustaining source of certainty, some guide to authenticity, some insight into the difference between the sacred and the profane, some method whereby one could, as it was said, distinguish an urn from a chamberpot, was a dominant characteristic of German historical pondering. Germans were haunted by the figure of Johann

Winckelmann, who, in the eighteenth century, had confidently rec-
ognized the Apollo Belvedere, the Aphrodite of Cyrene, and the
Albani Pallas as representatives of the canon of beauty and had
dismissed, with equal confidence, a statue of the drunken Hercules
as a caricature and thus ugly. The late nineteenth-century painter
Anselm Feuerbach wrote: "I am afraid of the unimaginativeness and
emptiness which now rule the world; we must return to the old
gods. It is impossible to turn to the future, for what future can be in
store for the men of money and machines?"[7] Hardly a single impor-
tant German historian would have seriously disagreed with Feuer-
bach's statement, and all were obsessed with the idea that some
dimly perceived heroic past could be made to speak to the confusing
present. Thus art must be recognizable in the sense that it must refer
to some experience or idea lodged in the collective mind. The work
of art must relate to the world outside the object itself and allow a
response conditioned by the knowledge and insights drawn from
religion, history, and what was termed enlightened sentiment.

 For those of such persuasion, the disappearance of the tradi-
tional, familiar artistic image indicated not only the senselessness of
the arts but also the decline of learning, the decay of religion and the
family, the loss of historical vigor, the end of morality. The direc-
tion of art must be the direction of history, and the abandonment of
what was called "our traditional artistic technique" was the conse-
quence of a historical breakdown. Hitler's attack upon modern art
can thus best be viewed as part of his attempt to rescue what he saw
as European history. As he stated, "we must master our distress, or
our distress will master us." He expressed, in a crude and brutal
fashion, the fears and hatreds of those who were uncomfortable in
the modern world, who were haunted by the idea of decadence and
decline, and who believed that it was possible by an act of will to
reassert control over what they saw as an errant European history.
In a speech in Berlin in May 1935, he spoke of the period of World
War I and immediately after:

> A writer has summed up the impressions made on him by this time in
> a book which he entitled "The Decline of the West." Is it then really
> to be the end of our history and of our peoples? No! We cannot
> believe it. This age must be called not the decline of the West, but the
> resurrection of the peoples of this West of ours.[8]

On another occasion, he was to say: "I've always rebelled against the

idea that Europe had reached the end of its mission, and that the hour of Russia or the United States had come."⁹ For him, Europe was not to disappear as a drop in the bloodstream of mankind but was to be maintained as a unique, distinctive, historical force. Hitler, in truth, posed an argument (although in a vulgarized fashion) similar to that stated by the character Möllberg in André Malraux's *The Walnut Trees of Altenburg,* who contends that the less human beings are defined by and participate in specific cultures, the more they resemble each other and the more they fade away as definable personalities. Thus the unity and permanence of man can be conceived, but it is a unity and a permanence of nothingness. The European without racial identity, without a clear, aesthetic image of himself, without a heroic response to life, is only a member of the human race, similar to the African and the Asian. In 1932 Gottfried Benn wrote: "The white race is at an end." Benn meant, of course, that the sands had run out on the European historical adventure, that Europe was no longer a formative force in the world and the Europeans no longer the activists but the victims. It was to this declaration that Hitler answered—No!

Unquestionably, much of Hitler's political success was related to his argument that the Germans could protect themselves from the destructive elements of the twentieth century, could isolate themselves from those influences that indicated decline. To extrapolate from Marc's statement, Hitler believed that the Germans did not have to "live among strange faces," did not have to look at "new pictures," and did not have to listen to "unheard-of sounds." He thought that it was possible to effect an immunization of the German people against the cultural infections afflicting other societies. In 1942 Robert Ley, leader of the Nazi Labor Front, in addressing a group of factory workers, asked his listeners: "Why do the German people love Hitler?" And he answered his own question: "Because with Hitler they feel safe—it is a feeling of safety, that's it."¹⁰ Apprehension about the modern world could be contained and a sense of security restored, historical nausea could be overcome, and the traditional loneliness of the Germans ended in a gathering-together and the elimination of all those offending qualities of a hated and mistrusted contemporary world.

And the entire effort was a deadly monstrosity. The belief that it was possible to rise above the ambiguities of modern life and to endow classical historical virtues with spirit was shown to be a

dangerous fantasy. Hitler's idea of a rejuvenated Mediterranean cul-
ture was stunted and diseased, a concept that could express itself
only in stilted monumentalism and empty gestures. European art
and European history could no longer incorporate any glimpse of the
racial hero, any memory of the grand historical act, any dream of
continental glory. A contemporary artist—German or otherwise—
could be a witness. But there was no longer any possibility of a
painter or a sculptor being a prophet. Nor could the artist respond to
Julius Langbehn's challenge to become an educator of the race. Little
of what had been traditionally regarded as characteristic of the Euro-
pean condition had anything to do with the actual human circum-
stances of European life in the twentieth century. To speak of a
European image of man, and to attempt to forward such an interpre-
tation, became inevitably a reactionary undertaking. As early as
1910, the poet Gottfried Benn noted that "all the timbers started
creaking," and by the time Hitler came to power, the house of
German art, as of German history, was in such disrepair as to be
beyond salvage.

In his memoirs Barlach wrote of the discovery he had made
during his short trip to Russia in 1906:

> A mighty realization burst upon me, and this is what it was: To you is
> given to express, without reserve, all that is within you—the utter-
> most, the innermost, the gentle gesture of piety and the rude gesture
> of rage—because for everything, be it paradise, hell, or one in the
> guise of the other, there is expressive form.[11]

Here there can be no static and unquestioned view of human exis-
tence but only variable and unstable images. The artist is free to
select whatever he or she wishes and to present such a selection in an
independent manner. Meyer Schapiro has noted that "modern
painting is the first complex style in history which proceeds from
elements that are not pre-ordered as closed articulated shapes." And
he continues:

> Yet it must be said that what makes painting and sculpture so interest-
> ing in our time is their high degree of non-communication. You can-
> not extract a message from painting by ordinary means; the usual
> rules of communication do not hold, there is no clear code or fixed
> vocabulary, no certainty of effect in a given time of transmission or
> exposure.[12]

Hitler held tightly to the belief that a given subject could be made into a picture. Modern art, however, has largely accepted the opposite supposition: it is not the picture which corresponds to the subject, but the subject that may correspond to the picture. The illusionist resemblance has been abandoned. Klee is an excellent authority on the subject:

> In earlier days, people represented things which they saw on earth, or like to see, or would have liked to see. Now that the relativity of visible things is becoming evident the conviction is strengthened that in relation to the whole universe visual truth is only one of many and that other truths exist in potentially vaster numbers. Objects appear in so many expanded and varied ways that they seem to contradict the rational experience of yesterday. People are trying to give essential form to what is accidental.[13]

Bradley F. Smith writes that Hitler had "a desire to escape from the world of hard realities into a world of romance colored by majestic art and sonorous music."[14] In modern art, however, there are no romances: the objects—dumb, persistent, challenging, and even sinister—force themselves upon us, without heroic overtones or historical consolation. At most, modern German art suggested ambiguous formulations of cultural and historical questions, revealing the profoundly problematic condition of Germany, and Europe, in the twentieth century. The search for the noble, the grand, the uplifting has come to an end.

In his novel *Dog Years*, Günter Grass presents a dramatic description of the German cultural experience in this century. One of his characters says that the Germans have had a dream of building something "which will burn, spark, and blaze everlastingly, yet never be consumed, but continue in all eternity, forever and ever, by its very nature, apocalypse and ornament in one, to burn, spark, and blaze." Later in the novel, however, we discover that the trail of German history, and we could say German art, has led to the tiled toilets of the central station in Cologne. Here men stand at the urinals and "look ahead with mournful eyes, and decipher inscriptions, dedications, confessions, prayers, outcries, rhymes, and names, scribbled in blue pencil or scratched with nail scissors, leather punch, or nail."

Hitler claimed that he had been the greatest liberator in the history of mankind, in that he had freed individuals from the bur-

dens of conscience and choice that few had the strength to carry. In a similar manner, he attempted to free the artist from modern creative loneliness and to bring him safely back into the classical discipline, to reestablish the canon of beauty and inspired propriety, and to relieve the pain of alienation. He expressed this idea crudely and simplistically. And the situation could not be otherwise. He stood at the end of a German tradition stressing the wholeness of culture and the belief that any society must have a moral, aesthetic, and intellectual consensus, and by the nineteen-twenties and nineteen-thirties such an interpretation had become so shoddy, so defensive, and so empty of content that anyone supporting it could muster only stale thought, repetitious cliches, and woolly meanderings.

The dead-end nature of such attempts to assert the reality of what has disappeared is well illustrated by Peter Gay in his *Weimar Culture: The Outsider as Insider.* Gay comments upon the last book, published in 1946, by the German historian Friedrich Meinecke. In his book Meinecke presents what he calls "a little wishful picture." He proposes that, in order to protect the permanent values of the German society, now shattered by the events of World War II, every German city and larger village should create "a community of like-minded friends of culture." Such communities would undertake the task of "conveying to the hearts of listeners through sound the most vital evidences of the great German spirit, always offering the noblest music and poetry together." Meetings would be called at regular intervals so that the German tradition could be passed on, and such meetings would be held, "if at all possible, in a church. The religious basis of our poetry justifies, yes demands, its being made clear by a symbolic procedure of this kind." Participants could thus find shelter from the terrors of the contemporary age and lose themselves in contemplating "lyrics of the wonderful sort, reaching their peak in Goethe and Mörike where the soul becomes nature and nature the soul, and sensitive, thoughful poetry like that of Goethe and Schiller." Gay writes of this proposal:

> In the impressive literature of German self-accusation, I know of no passage more instructive and more pathetic than this. By blurring the boundaries between poetry and religion, Meinecke perpetuates that vague religiosity of the heart that had characterized so much German philosophizing since the end of the eighteenth century—since the fatal years when the poets and thinkers of the classical period thought it necessary to "overcome" the "shallow thinking" of the Enlighten-

ment. Reading poetry in a church, at stated hours, is a notion symptomatic of an intellectual style that raises poetry to religious importance and degrades religion to poetic feeling, permitting devotees to feel cultured without being materialists, and pious without being saddled with particular Christian dogmas which, everyone knew, are mere superstitions.

Gay is particularly offended, and rightly so, by the supposition that, in some mysterious way and in spite of all we have learned about life in this century, there could be any thought of a separation of "the higher realm of self-perfection, *Bildung*, the achievement of *Kultur* for its own sake," and "the lower realm of human affairs, sordid with practical matters and compromises."[15]

The German novelist Ernst Jünger noted in his diary in April 1945:

> From such a defeat one does not recover any longer, as people formerly recovered after Jena or after Sedan. Such a defeat marks a turning-point in the life of nations, and in such a transition not only innumerable human beings must die but also much that moved us in our very depths.[16]

Jünger is here referring to Germany, but his statement has a wider implication. The cultural landscape of Europe has been drastically altered, and the great forms that had expressed the European experience, under stress for a century, have collapsed. Many of the definitions of European life are as obsolete as the figure of the uniformed and monocled Prussian officer who sits lost in memories as he listens to recorded military music. The English gentleman, the French high bourgeois, the German hero—now flawed remnants of once-powerful symbols. The "tribes" of Europe have been permanently transformed, and their monuments remain as respected but charred and battered hulks in an alien environment. Joachim Fest, in *The Face of the Third Reich*, has described this transformation in words that are certain to call forth agreement by any who have some knowledge of the Europe that existed prior to the triumph of the Nazis:

> Hitler did not destroy Germany alone, but put an end to the old Europe, with its sterile rivalries, its narrow-mindedness, its selfish patriotism, and its deceitful imperatives. He put an end too to its

splendor, its grandeur, and the magic of its *douceur de vivre*. The hour of Europe is past, and we shall never see it again.[17]

Hitler the historical figure is safely dead. But the sneering ghost of Hitler the artist may cause us an occasional moment of aesthetic uneasiness. We want none of the posed, stale heroism of which he was so fond, but we often have a faint, lingering hope that art might speak to our history and present at least a glimpse of certainty. We do fear that we might be in the presence of some blasphemy, or are being ridiculed, when we hear that in response to the question of whether his *The Man with the Sheep* might not be a religious or timeless symbol, Picasso remarked: "It isn't religious at all. The man could carry a pig instead of a sheep. There is no symbolism in it." As Hannah Arendt correctly noted:

> The end of a tradition does not necessarily mean that traditional concepts have lost their power over the minds of men. On the contrary, it sometimes seems that this power of well-worn notions and categories becomes more tyrannical as the tradition loses its living force and as the memory of its beginning recedes.[18]

Thus we are tempted to flee our contemporary loneliness and to seek refuge in some safehouse of ancient values. But we quickly awaken to our true situation, to our modern aesthetic awareness, to the wonder of twentieth-century art, and discard our nostalgic and destructive yearnings for an unexamined security. A brief glance at the model of what was to be Hitler's new Berlin, that expression of a nightmare of perfect order, of sterile balance, of crippled serenity, is enough to disabuse us and restore our allegiance to the disorderly, confusing, but enriched world of modern art and modern history.

For the greater part of the last two centuries, the creative Western European has been engaged in an effort to break out into a wider world, to escape the confines of a Mediterranean-based culture. And modern art can be viewed as a dramatic manifestation of this urge toward a true cosmopolitanism. Schapiro has pointed out that modern painting and sculpture have aimed at an "unhistorical universalizing" of art, and that the "notion of the humanity of art was immensely widened." The pristine ideal of a distinctive European image was abandoned, as was the claim to a hierarchy of cultures, whereby Europe could exist as a self-contained aesthetic entity, indifferent to and uncontaminated by Asia, Africa, or

America. Hitler's actions, in the area of art as elsewhere, were desperate attempts to bind Europe to a single vision, to dull the "hot" innovative thrust of modernity and to reintroduce a "cold" cultural environment, where historical and aesthetic equilibrium and continuity could be maintained. In pursuing this goal, he mounted a deadly attack upon what must be regarded as the true greatness of Europe, upon those values that made Europe, as Albert Camus wrote in his *Letters to a German Friend*, "a home of the spirit," a "privileged arena," wherein Western man struggled "against the world, against the gods, against himself." In his animosity toward modern art, Hitler showed his hatred of what must be called the deeper reaches of the European experience. Siegfried Kracauer, in his *From Caligari to Hitler: A Psychological History of the German Film*, presents an arresting description of the emptiness of Hitler's aesthetic vision and of the shallowness, the sterility, the deadliness, of his interpretation of European history. Kracauer concludes his book with a summary of a German newsreel sequence of Hitler's 1940 visit to Paris:

> The columns of the Madeleine sternly watch as he paces up the steps. Then the Nazi cars pass before the Opéra. They cross La Concorde, drive along the Champs-Elysées and slow down in front of the Arc de Triomphe. . . . On they drive. At the end, Hitler and his retinue stand on the terrace of the Trocadéro, steadfastly gazing at the Eiffel Tower in the rear. The Führer is visiting the conquered European capital—but is he really its guest? Paris is as quiet as a grave. Except for a few policemen, a worker and a solitary priest hastening out of sight, not a soul is to be seen at the Trocadéro, the Etoile, the huge Concorde, the Opéra and the Madeleine, not a soul to hail the dictator so accustomed to cheering crowds. While he inspects Paris, Paris itself shuts its eyes and withdraws. The touching sight of this deserted ghost city that once pulsed with feverish life mirrors the vacuum at the core of the Nazi system. Nazi propaganda built up a pseudo-reality iridescent with many colors, but at the same time it emptied Paris, the sanctuary of civilization.[19]

NOTES

Chapter 1: The Artist in Politics

1. *Mein Kampf*, translated by Ralph Manheim (Boston: Houghton Mifflin, 1943), p. 255.

2. Letter of December 5, 1937, to Friedrich Düsel, *Ernst Barlach: Die Briefe*, edited by Friedrich Dross (Munich: R. Piper, 1969), vol. II, p. 742. A cast of the *Warrior of the Spirit* survives at the Minneapolis Institute of Arts.

3. Letter of December 27, 1930, to Reinhard Piper, ibid., p. 245.

4. Letter of April 11, 1933, to Reinhard Piper, *Ernst Barlach: Aus seinen Briefen*, edited by Friedrich Dross (Munich: R. Piper, 1947), p. 61.

5. See Alfred Werner, *Ernst Barlach* (New York: McGraw Hill, 1966), p. 168. The text of the attack upon Barlach in *Das Schwarze Korps* appears in *Ernst Barlach: Werk und Wirkung*, edited by Elmar Jansen (Frankfurt/Main: Athenäum, 1972), pp. 464–67.

6. Information on confiscations by the Nazis appears in Franz Roh, *"Entartete" Kunst: Kunstbarbarei im Dritten Reich* (Hannover: Fackelträger Verlag, 1962); Hellmut Lehmann-Haupt, *Art under a Dictatorship* (New York: Oxford University Press, 1954); and Ian Dunlop, *The Shock of the New* (New York: McGraw-Hill, 1972).

7. An informative commentary upon controversies stirred by modern art in Germany in the years prior to World War I is Marion F. Deshmukh, "Max Liebermann: Observations on the Politics of Painting in Imperial Germany, 1870–1914," *German Studies Review* 3, no. 2 (1980): 171–206.

8. *Hitler's Table Talk, 1941–44: His Private Conversations*, translated by Norman Cameron and R. H. Stevens (London: Weidenfeld & Nicolson, 1973), p. 444. The declaration of 1942 provided that owners of works by Hitler were to register them with the government and that these works could not be sold abroad without specific permission.

9. Quoted in Konrad Heiden, *Der Fuehrer: Hitler's Rise to Power*, translated by Ralph Manheim (Boston: Houghton Mifflin, 1944), pp. 365–66.

10. Hitler's "Address on Art and Politics" at Nuremberg, September 11, 1935, in Norman H. Baynes, *The Speeches of Adolf Hitler, April 1922–August 1939* (New York: Howard Fertig, 1969), vol. I, p. 570.

11. *Table Talk*, pp. 250–51.

12. Ibid., p. 11.

13. Heiden, p. 284.

14. Robert Gutman, *Richard Wagner: The Man, His Mind, and His Music* (New York: Harcourt, Brace, & World, 1968), p. 121.

15. Heiden, p. 362.

16. Baynes, *The Speeches of Adolf Hitler*, vol. I, pp. 569ff.

17. Ibid.

18. Friedrich Percyval Reck-Malleczewen, *Diary of a Man in Despair*, translated by Paul Rubens (London: Macmillan, 1970), p. 23. Orwell's statement, which has occasionally been erroneously cited as a defense of Hitler, appears in George Woodcock, *The Crystal Spirit* (Boston: Little, Brown, 1966), p. 57.

19. Sontag's review of Syberberg's film appeared in the *New York Review of Books* (February 21, 1980), p. 36. Sontag has a warning for those who would attempt to approach Hitler "creatively": "The pasticheur's style is essentially a style of fantasy."

20. Friedrich Dürrenmatt, *Problems of the Theatre* and *The Marriage of Mr. Mississippi* (New York: Grove Press, 1964), p. 29.

21. Charlotte Beradt, *The Third Reich of Dreams*, translated by Adriane Gottwald (Chicago: Quadrangle, 1968), p. 111.

22. Volodymyr Walter Odajnyk, *Jung and Politics* (New York: New York University Press, 1976), p. 102. Extended reviews of various, even bizarre, interpretations of Hitler are William W. MacDonald, "The *Hitler Welle:* The Historians' Search for Adolf Hitler" and "Adolf Hitler and the Psychohistorians," *Research Studies* 46, nos. 1 and 2 (1978): 54–68, 117–39. See also Hugh Trevor-Roper, "Was halten Sie von Hitler, Doktor? Überraschungen im Zauberland der Psycho-Historie," *Die Zeit* (April 20, 1973), pp. 23–24.

23. Ziegler's *Adolf Hitler aus dem Erleben dargestellt* (Göttingen: K. W. Schütz, 1964) is a defense of the artistic attitudes associated with Hitler. Ziegler notes that as early as 1912 he had become alarmed at the direction of modern art, which was "a clear proclamation of the Jewish control of culture in Germany," and had become aware that the natural German urge for clarity and order was being frustrated by modernist tendencies toward irrationality and disorder.

24. Eberhard Jäckel, *Hitler's Weltanschauung: A Blueprint for Power*, translated by Herbert Arnold (Middletown Conn.: Wesleyan University Press, 1972), p. 87.

25. Werner Maser, *Hitler: Legend, Myth and Reality*, translated by Peter and Betty Ross (London: Harper & Row, 1973), p. 5.

26. *Table Talk*, pp. 316–17.

27. Baynes, *The Speeches of Adolf Hitler*, vol. I, p. 567.

28. Harold Rosenberg, *Discovering the Present: Three Decades in Art, Culture, and Politics* (Chicago: University of Chicago Press, 1973), p. 99.

29. *Mein Kampf*, p. 172.

30. Baynes, *The Speeches of Adolf Hitler*, vol. I, p. 678.

31. *Table Talk*, p. 82.

32. *Mein Kampf*, p. 290.

33. Baynes, *The Speeches of Adolf Hitler*, vol. I, p. 588.

34. Ibid., p. 579.

35. *Mein Kampf*, p. 258.

36. Klee's lecture was published in Switzerland in 1945 as *Über die moderne Kunst* and appears in an English translation by Paul Findlay as *Paul Klee on Modern Art* (London: Faber and Faber, 1948).

37. Marc's comments are in his articles in the 1912 edition of the anthology *Der Blaue Reiter* and may be consulted in *The Blaue Reiter Almanac*, edited by Klaus Lankheit (New York: Viking, 1974), pp. 55–71. Schlemmer's letter—to an unidentified recipient, written "in the field" and dated May 1918—appears in *The Letters and Diaries of Oskar Schlemmer*, edited by Tut Schlemmer and translated by Krishna Winston (Middletown, Conn.: Wesleyan University Press, 1972), p. 50.

38. Quoted by Barbara Miller Lane, *Architecture and Politics in Germany, 1918–1945* (Cambridge, Mass.: Harvard University Press, 1968), p. 45.

39. Letter to Otto Meyer, July 10, 1913, in *Letters and Diaries of Oskar Schlemmer*, p. 14.

40. Baynes, *The Speeches of Adolf Hitler*, vol. I, p. 610.

Chapter 2: The Viennese Experience

1. *Mein Kampf*, translated by Ralph Manheim (Boston: Houghton Mifflin, 1943), p. 58.

2. Quoted by Werner Maser, *Hitler: Legend, Myth and Reality*, translated by Peter and Betty Ross (London: Harper & Row, 1973), p. 33.

3. Scholarly examinations of Hitler's life in Vienna are provided by Franz Jetzinger, *Hitler's Youth*, translated by Lawrence Wilson (London: Hutchinson & Co., 1958); William Jenks, *Vienna and the Young Hitler* (New York: Columbia University Press, 1960); and Bradley F. Smith, *Adolf Hitler: His Family, Childhood, and Youth* (Stanford: Stanford University Press, 1967). An interesting study of the period during which Hitler was in Vienna is William M. Johnston, *The Austrian Mind* (Berkeley: University of California Press, 1972).

4. *Mein Kampf*, p. 27.

5. Ibid., pp. 22, 125.

6. Ibid., p. 56. Lanz von Liebenfels (Adolf Josef Lanz), a well-known Viennese racist pamphleteer, argued that it was one of his publications that Hitler bought in 1909 and that the young Hitler even sought him out in order to secure some copies of Liebenfels' *Ostara: Newsletters of the Blond Fighters for the Rights of Man*. Liebenfels was an impossible eccentric, who, however, had a surprising number of readers, including August Strindberg, Horatio Herbert Kitchener, Carl Peters, the "Proconsul" of German East Africa, Mathilde Ludendorff, and Professor Carl Penka, who achieved some notoriety for his theory that northern Germany was the original home of the Homeric heroes. Wilfried Daim, in *Der Mann, der Hitler die Ideen gab* (Munich: Isar Verlag, 1958), provides all the information most would care to have about Liebenfels.

7. *Mein Kampf*, p. 64.

8. Ibid., pp. 56, 325.

9. Ibid., pp. 257–58.

10. Ibid., p. 58.

11. Ibid., p. 57.

12. Meyer Schapiro, *Modern Art: 19th and 20th Centuries* (New York: George Braziller, 1978), pp. 138, 142.

13. Quoted by Walter Koschatzky and Horst-Herbert Kossatz, *Ornamental Posters of the Vienna Secession* (New York: St. Martin's Press, 1974), p. 21.

14. A good summary of artistic activities in Vienna in the early years of the twentieth century is Peter Vergo, *Art in Vienna 1898–1918* (London: Phaidon, 1975). For an examination of the characteristics of Viennese art that were offensive to Hitler, see Alessandra Comini, *The Fantastic Art of Vienna* (New York: Knopf, 1978).

15. An account of the provincialism of German art criticism of the turn of the century is in Kenworth Moffett, *Meier-Graefe as Art Critic* (Munich: Prestel-Verlag, 1973). As examples Moffett mentions Adolf Rosenberg's 1884 history of modern art where only 8 pages of over 400 are devoted to Impressionism; the 1896 Berlin international showing where of some 4,000 so-called modern works on exhibit there was not one Impressionist or Post-Impressionist painting; and Friedrich Haacks' *The Art of the 19th Century* of 1905, where, in 400 pages, Van Gogh and Gauguin receive a single paragraph while Seurat and Cézanne are not mentioned.

16. Hofer's essay appeared in *Omnibus Almanach für das Jahr 1932*, published in Berlin, and an English translation is in Orrel P. Reed, *German Expressionist Art: The Robert Gore Rifkind Collections* (Los Angeles: Frederick S. Wight Art Gallery and University of California, Los Angeles, 1977), p. 146.

17. Quoted in Lothar-Günther Buchheim, *The Graphic Art of German Expressionism* (New York: Universe Books, 1960), pp. 42–44.

18. An analysis of the Beckmann-Marc controversy appears in Peter Selz, *German Expressionist Painting* (Berkeley: University of California Press, 1974 edition), pp. 238–40.

19. Quoted in Ian Dunlop, *The Shock of the New* (New York: McGraw-Hill, 1972), p. 151.

20. *The Diaries of Paul Klee, 1898–1918*, edited by Felix Klee (Berkeley and Los Angeles: University of California Press, 1964), pp. 125, 266.

21. Bradley F. Smith, *Adolf Hitler: His Family, Childhood and Youth*, p. 153.

22. Quoted in Maser, p. 71.

23. *Mein Kampf*, p. 293.

Chapter 3: In Munich with Dietrich Eckart

1. *Hitler's Table Talk, 1941–44: His Private Conversations*, translated by Norman Cameron and R. H. Stevens (London: Weidenfeld & Nicolson, 1973), p. 217.

2. *The Diaries of Paul Klee, 1898–1918*, edited by Felix Klee (Berkeley and Los Angeles: University of California Press, 1964), p. 315.

3. See Theo Shapiro, *Painters and Politics: The European Avant-Garde and Society, 1900–1925* (New York: Elsevier, 1976), for a discussion of the political proclivities of artists in the immediate post-World War I period.

4. Letter of January 29, 1938, to Stephan Lackner, quoted in Lackner, *Max Beckmann: Memories of a Friendship* (Coral Gables, Fl.: University of Miami Press, 1969), p. 38.

5. A brief discussion of the tortured relationship of Emil Nolde and the Nazis is

Robert A. Pois, "The Cultural Despair of Emil Nolde," *German Life and Letters* 25 (1971–72): 252–60.

6. See Hofer's essay "What Is German Art?" as given in Orrel P. Reed, *German Expressionist Art: The Robert Gore Rifkind Collections* (Los Angeles: Frederick S. Wight Art Gallery and University of California, Los Angeles, 1977), p. 146.

7. *Mein Kampf*, translated by Ralph Manheim (Boston: Houghton Mifflin, 1943), p. 161.

8. *Table Talk*, p. 141.

9. Ibid., p. 217.

10. There are a number of biographies of Dietrich Eckart written by Nazis or Nazi sympathizers: Alfred Rosenberg, *Dietrich Eckart: Ein Vermächtnis* (Munich: F. Eher, 1928); Albert Reich, *Dietrich Eckart: Ein deutscher Dichter und der Vorkämpfer der völkischen Bewegung* (Munich: F. Eher, 1933); Raimund Lembert, *Dietrich Eckart: Ein Künder und Kämpfer des Dritten Reiches* (Munich: F. Eher, 1934); Richard Euringer, *Dietrich Eckart: Leben eines deutschen Dichters* (Hamburg: Hanseatische Verlagsanstalt, 1935); and Wilhelm Grün, *Dietrich Eckart als Publizist* (Munich: Hoheneichen Verlag, 1941). The greater part of the material in these books is uncritical and tiresome. Grün's book does contain a sixty-seven–page bibliography of Eckart's writings and of published comments about him through 1938. Grün also provides a genealogy of Eckart's family that reaches back to 1285 and shows a blood line that should have satisfied the most exacting of Nazi racial purists. Margareta Plewnia's *Auf dem Weg zu Hitler: Der "völkische" Publizist Dietrich Eckart* (Bremen: Schünemann Universitätsverlag, 1970) is a scholarly and valuable work.

11. *Table Talk*, p. 156.

12. A perceptive examination of *Der Bolschewismus von Moses bis Lenin* is Ernst Nolte's "Eine frühe Quelle zu Hitlers Antisemitismus," *Historische Zeitschrift* 112, no. 3 (June 1961): 584–606.

13. Robert Gutman, *Richard Wagner: The Man, His Mind, and His Music* (New York: Harcourt, Brace, & World, 1968), p. 121.

14. In 1933 the Nazi poet Hanns Johst in his essay "Was Ist Kulturbolschewismus?" declared that cultural Bolshevism was a denial of heroism and a rejection of the classic tragic potentialities of the Germans.

15. The German text of the poem appears in Plewnia, *Auf dem Weg zu Hitler*, p. 112.

Chapter 4: The Confrontation

1. Quoted in Victor H. Miesel, ed., *Voices of German Expressionism* (Englewood Cliffs, N.J.: Prentice-Hall, 1970), p. 9.

2. Hildegard Brenner, "Art in the Political Power Struggle of 1933 and 1934," in *Republic to Reich: The Making of the Nazi Revolution*, edited by Hajo Holborn (New York: Pantheon, 1972), p. 424.

3. Studies of the general Nazi policy toward the arts are Paul Rave, *Kunstdiktatur im Dritten Reich* (Hamburg: Verlag Gebrüder Mann, 1949); Hellmut Lehmann-

Haupt, *Art under a Dictatorship* (New York: Oxford University Press, 1954); Franz Roh, *"Entartete" Kunst, Kunstbarbarei im Dritten Reich* (Hannover: Fackelträger Verlag, 1962); Hildegard Brenner, *Die Kunstpolitik des Nationalsozialismus* (Hamburg: Rowolt, 1963); Barbara Miller Lane, *Architecture and Politics in Germany, 1918–1945* (Cambridge, Mass.: Harvard University Press, 1968); and Berthold Hinz, *Art in the Third Reich* (New York: Pantheon, 1979).

4. See Carl Dietrich Carls, *Ernst Barlach* (New York: Praeger, 1969), p. 172.

5. Benn's essay first appeared in *Deutsche Zukunft* and then in 1934 in *Kunst und Macht* (Stuttgart). An English translation appears in Miesel, pp. 192–203.

6. Hitler's comments appear in Hildegard Brenner, "Art in the Political Power Struggle of 1933 and 1934," in *Republic to Reich*, pp. 395–432. Brenner's is an excellent analysis of these controversies.

7. Quoted in Ian Dunlop, *The Shock of the New* (New York: McGraw-Hill, 1972), p. 235.

8. Norman H. Baynes, *The Speeches of Adolf Hitler, April 1922–August 1939* (New York: Howard Fertig, 1969), vol. I, p. 500.

9. Ibid., p. 509.

10. *Hitler's Table Talk, 1941–44: His Private Conversations*, translated by Norman Cameron and R. H. Stevens (London: Weidenfeld & Nicolson, 1973), p. 716.

11. Hildegard Brenner, in *Ende einer bürgerlichen Kunst-Institution* (Stuttgart: Deutsche Verlagsanstalt, 1972), provides an extended discussion of the Nazi "cleansing" of the Prussian Academy of Arts.

12. Letter to Goebbels, July 2, 1937, in Miesel, pp. 209–10.

13. Quoted in Alfred Werner, *Ernst Barlach* (New York: McGraw-Hill, 1966), p. 29.

14. *The Letters and Diaries of Oskar Schlemmer*, edited by Tut Schlemmer and translated by Krishna Winston (Middletown, Conn.: Wesleyan University Press, 1972), pp. 310–11.

15. Ibid., pp. 316–19.

16. Quoted by Stephan Lackner, *Max Beckmann: Memories of a Friendship* (Coral Gables, Fl.: University of Miami Press, 1969), p. 20.

17. Letter of June 13, 1933, *The Letters and Diaries of Oskar Schlemmer*, p. 313.

18. Wiechert wrote an account of his imprisonment. Entitled *Der Totenwald*—an obvious reference to Buchenwald—the manuscript was concealed by Wiechert and was only published in 1945.

19. Quoted by Franz Roh, *German Art in the 20th Century*, translated by Catherine Hutter (Greenwich, Conn.: New York Graphic Society, 1968), p. 331.

20. Liebermann's wife committed suicide in 1943 to avoid being transported to an extermination camp.

21. Werner Haftmann, *Emil Nolde: Unpainted Pictures*, translated by Inge Goodwin (New York: Praeger, 1965), p. 39.

22. Baynes, vol. I, p. 598.

23. Percy Ernst Schramm, *Hitler: The Man and the Military Leader*, translated by Donald S. Detwiler (London: Quadrangle, 1972), p. 22.

24. *Mein Kampf*, translated by Ralph Manheim (Boston: Houghton Mifflin, 1943), p. 423.

25. Konrad Heiden, *Der Fuehrer: Hitler's Rise to Power*, translated by Ralph Manheim (Boston: Houghton Mifflin, 1944), p. 363.

26. Quoted by Baynes, vol. I, p. 567.

27. Quoted by Werner Maser, *Hitler: Legend, Myth and Reality*, translated by Peter and Betty Ross (London: Harper & Row, 1973), p. 155.

28. *Table Talk*, p. 566.

29. Ibid., p. 255.

30. Ibid., p. 248.

31. Quoted in Lehmann-Haupt, p. 97.

32. Heiden, p. 366.

33. Quoted in Maser, p. 58.

34. Wayne Andersen, *Gauguin's Paradise Lost* (New York: Viking, 1971), pp. 52–53.

35. Ernst Scheyer, *The Circle of Henry Adams: Art and Artists* (Detroit: Wayne State University Press, 1970), p. 25.

36. *Table Talk*, p. 151.

37. Ibid., p. 371.

38. *Mein Kampf*, p. 254. Ludwig Leiss, in *Kunst in Konflikt* (Berlin: de Gruyter, 1971), examines the tensions set off in Germany during the twentieth century by the erotic, at times pornographic, aspects of modern art.

39. Beth Irwin Lewis, *George Grosz: Art and Politics in the Weimar Republic* (Madison, Wis.: University of Wisconsin Press, 1971), pp. 162–63.

40. Baynes, vol. I, p. 574.

41. Richard Grunberger, *A Social History of the Third Reich* (London: Weidenfeld & Nicolson, 1971), p. 25.

42. Lehmann-Haupt, p. 89.

43. Quoted in Susan Sontag, "Fascinating Fascism," *New York Review of Books* (February 6, 1975), pp. 25–26.

44. *Table Talk*, pp. 151, 688.

45. Gottfried Lindemann, *History of German Art*, translated by Tessa Sayle (New York: Praeger, 1971), p. 159.

46. Lehmann-Haupt, p. 91.

47. On June 13, 1943, Hitler remarked: "I cannot make up my mind to buy a picture by a French painter, because I am not sure of the dividing line between what I understand and what I do not understand." *Table Talk*, pp. 703–04.

48. Janet Flanner, *Men and Monuments* (New York: Harper, 1957), p. 226.

49. See H. R. Trevor-Roper, *The Last Days of Hitler* (New York: Macmillan, 1947), p. 181.

50. *The Blaue Reiter Almanac*, edited by Klaus Lankheit (New York: Viking, 1976), p. 66.

51. Baynes, vol. I, p. 207.

52. Joachim C. Fest, *The Face of the Third Reich: Portraits of the Nazi Leadership*, translated by Michael Bullock (New York: Pantheon, 1970), p. 203.

53. Quoted in Alfred Werner, p. 11.

Chapter 5: The Exhibition of Degenerate Art

1. Werner Haftmann, *Emil Nolde: Unpainted Pictures*, translated by Inge Goodwin (New York: Praeger, 1965), p. 13.

2. *Mein Kampf*, translated by Ralph Manheim (Boston: Houghton Mifflin, 1943), pp. 126–27.

3. Hans K. Roethel, *The Blue Rider*, translated by Hans K. Roethel and Jean Benjamin (New York: Praeger, 1971), pp. 31, 37.

4. Ian Dunlop, *The Shock of the New* (New York: McGraw-Hill, 1972), p. 238.

5. Quoted by Percy Ernst Schramm, *Hitler: The Man and the Military Leader*, translated by Donald S. Detwiler (London: Quadrangle, 1972), p. 66.

6. Richard Grunberger, *A Social History of the Third Reich* (London: Weidenfeld & Nicolson, 1971), p. 427.

7. Hitler's speech was published as "Der Führer eröffnet die Grosse Deutsche Kunstausstellung 1937," in *Die Kunst im Dritten Reich* (July–August 1937). This glossy, officially approved publication was later renamed *Die Kunst im Deutschen Reich*. An English translation of the address appears in Herschel B. Chipp, *Theories of Modern Art: A Source Book by Artists and Critics* (Berkeley: University of California Press, 1968), pp. 474–83.

8. Frederick S. Levine, in *The Apocalyptic Vision: The Art of Franz Marc as German Expressionism* (New York: Harper & Row, 1979), and Klaus Lankheit, in *Franz Marc: Der Turm der blauen Pferde* (Stuttgart: Reclam, 1961), suggest that Hitler agreed with these protests and ordered that Marc's works be removed from the exhibition. The evidence in support of this contention is not overly persuasive.

9. Quoted by Dunlop, p. 253.

10. See Heinrich Hoffmann, *Hitler Was My Friend*, translated by R. H. Stevens (London, 1955), cited by Dunlop, *The Shock of the New*, p. 253.

11. A reproduction of the catalog issued for the exhibition is in Franz Roh, *"Entartete" Kunst: Kunstbarbarei im Dritten Reich* (Hannover: Fackelträger Verlag, 1962).

12. In the spring of 1938 an exhibition opened in Düsseldorf with the title "Degenerate Music." Hindemith's works were prominently displayed and were put beside compositions by Schoenberg with the statement: "Who eats with Jews, dies of it."

13. The letter is given in Victor H. Miesel, ed., *Voices of German Expressionism* (Englewood Cliffs, N.J.: Prentice-Hall, 1970), p. 209.

14. *The Letters and Diaries of Oskar Schlemmer*, edited by Tut Schlemmer and translated by Krishna Winston (Middletown, Conn.: Wesleyan University Press, 1972), p. 367.

15. See Stephan Lackner, *Max Beckmann: Memories of a Friendship* (Coral Gables, Fl.: University of Miami Press, 1969), p. 66.

16. Quoted by Uwe Schneede, *Max Ernst*, translated by R. W. Last (New York: Praeger, 1973), p. 59.

17. *Hitler's Table Talk, 1941–44: His Private Conversations*, translated by Norman Cameron and R. H. Stevens (London: Weidenfeld & Nicolson, 1973), pp. 370–71.

18. Berthold Hinz, *Art in the Third Reich* (New York: Pantheon, 1979), p. 43.

19. In 1977 the Munich Staatsgalerie moderner Kunst purchased Beckmann's *The Temptation of Saint Anthony* from its American owner for some two million marks.

20. Hinz, p. 10.

21. *Table Talk*, p. 603.

22. Hellmut Lehmann-Haupt, *Art under a Dictatorship* (New York: Oxford University Press, 1954), p. 89.

Chapter 6: Modern Art and Modern History

1. Quoted by Franz Roh, *German Art in the 20th Century*, translated by Catherine Hutter (Greenwich, Conn.: New York Graphic Society, 1968), p. 75.

2. Harold Rosenberg, *Discovering the Present: Three Decades in Art, Culture, and Politics* (Chicago: University of Chicago Press, 1973), p. 98.

3. Franz Marc, *Briefwechsel* (Cologne: DuMont, 1964), pp. 39–40.

4. Beckmann's "Creative Credo," quoted in Victor H. Miesel, ed., *Voices of German Expressionism* (Englewood Cliffs, N.J.: Prentice-Hall, 1970), p. 109.

5. Quoted in Herbert Read, *Art and Alienation* (New York: Viking, 1970), p. 22.

6. Hayden White, *Metahistory: The Historical Imagination in Nineteenth-Century Europe* (Baltimore: Johns Hopkins University Press, 1973), p. 432.

7. Quoted by Gottfried Lindemann, *History of German Art*, translated by Tessa Sayle (New York: Praeger, 1971), p. 173.

8. Norman H. Baynes, *The Speeches of Adolf Hitler, April 1922–August 1939* (New York: Howard Fertig, 1969), vol. I, p. 630.

9. *Hitler's Table Talk, 1941–44: His Private Conversations*, translated by Norman Cameron and R. H. Stevens (London: Weidenfeld & Nicolson, 1973), p. 327.

10. Joachim C. Fest, *The Face of the Third Reich: Portraits of the Nazi Leadership*, translated by Michael Bullock (New York: Pantheon, 1970), p. 303.

11. See Alfred Werner, *Ernst Barlach* (New York: McGraw-Hill, 1966), p. 8.

12. Meyer Schapiro, *Modern Art: 19th and 20th Centuries* (New York: George Braziller, 1978), pp. 221, 223.

13. See Miesel, p. 86.

14. Bradley F. Smith, *Adolf Hitler: His Family, Childhood and Youth* (Stanford: Stanford University Press, 1967), p. 8.

15. Peter Gay, *Weimar Culture: The Outsider as Insider* (New York: Harper & Row, 1968), p. 68.

16. See Hans Kohn, "Rethinking Recent German History," in Hans Kohn, ed., *German History: Some New German Views* (Boston: Beacon, 1954), p. 26.

17. Fest, p. 67.

18. Hannah Arendt, *Between Past and Future: Six Exercises in Political Thought* (Cleveland and New York: World Publishing Co., 1963), p. 26.

19. Siegfried Kracauer, *From Caligari to Hitler: A Psychological History of the German Film* (Princeton: Princeton University Press, 1947), p. 307.

INDEX